IMAGES
of America

BAY VILLAGE

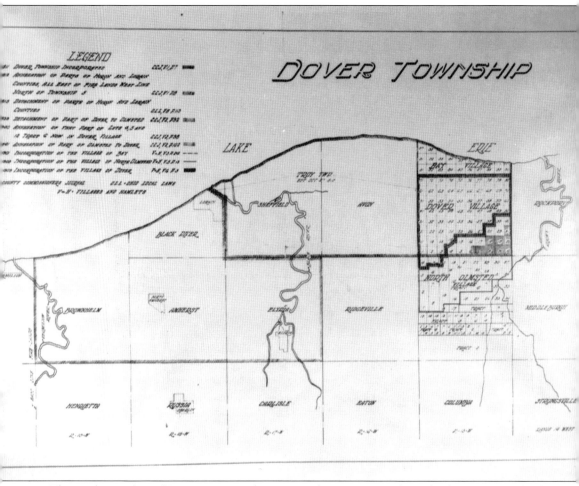

The civil township of Dover, organized on November 4, 1811, embraced a large tract of land totaling 25 miles along the shoreline west. It was annexed out as far as the Firelands. Townships and villages split off during the 19th century until only Bay Village, Westlake, and a corner of North Olmsted were left.

On the cover: The Cahoons celebrated each year with a family and pioneer reunion. This reunion took place about 1910. Some of the people seated are Helen Bulloch, Mineva Hollenbach, Abby Shneerer, Lydia Cahoon, Everett Cahoon, Ida Cahoon, Jenny French Andrews, and Laura Cahoon, with their family members standing behind. (Courtesy of the Bay Village Historical Society.)

IMAGES
of America

BAY VILLAGE

Virginia L. Peterson and Sally Irwin Price

ARCADIA
PUBLISHING

Published by Arcadia Publishing
Charleston SC, Chicago IL, Portsmouth NH, San Francisco CA

Printed in the United States of America

Library of Congress Catalog Card Number: 2007924631

For all general information contact Arcadia Publishing at:
Telephone 843-853-2070
Fax 843-853-0044
E-mail sales@arcadiapublishing.com
For customer service and orders:
Toll-Free 1-888-313-2665

Visit us on the Internet at www.arcadiapublishing.com

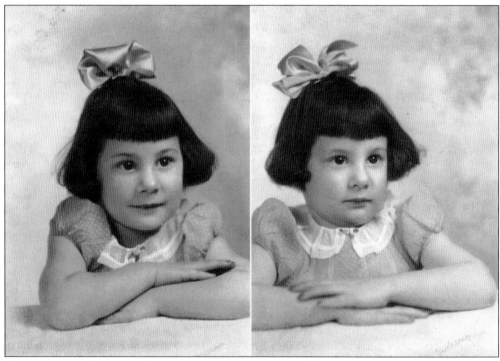

This book is dedicated to Gay Rothaermel Menning and Kay Rothaermel Laughlin, with the hope it inspires others to love their town and history. Menning and Laughlin are pictured here as little girls.

CONTENTS

ACKNOWLEDGMENTS

When we decided to do this book, we sought out a local historian to help us. There was only one person who came to mind—Kay Laughlin. Many years ago, Kay and her twin sister, Gay Menning, researched Bay Village, collecting various sources and interviewing citizens and families. They wrote the groundbreaking book *Bay Village, A Way of Life*, which has made researching our town history a much easier undertaking due to the wealth of information and material that they collected.

As twins, Gay and Kay shared everything, and history was their passion. They were taught by their father to love what came before and to treasure those gifts. Sadly, Gay passed away before this book was written, but her influence within these pages is unquestionable. Gay loved Bay Village and was proud of who she was and where she lived. This was an innate part of her being. We owe Kay a debt of gratitude for her writing and documenting of Bay Village history as well as gathering, saving, and organizing wonderful historical photographs. The majority of the images in this book are courtesy of Gay Menning and Kay Laughlin and the Bay Village Historical Society. Images from other sources are noted.

We would also like to thank Lee Peterson, who made so many contributions and suggestions to this book, and Marge Gulley, local artist and naturalist, whose illustrations begin each chapter. Gulley has depicted scenes and architecture, both current and historical, using ink and watercolor. Her work has been in many juried and nonjuried art shows throughout the region. She has created calendars, books, cards, and private collections and has a permanent exhibit at the Lake Erie Nature and Science Center in Bay Village.

INTRODUCTION

By all appearances, Bay Village, a suburb of Cleveland, seems to be a sleepy little hamlet tucked in the far western corner of Cuyahoga County. But appearances can be deceiving. Although Bay Village is only five and a half miles long and a mile wide at its widest point, it has been home to an inordinate number of people who have had an impact on history far beyond this small village. It is to these people and to the community that supported them that we dedicate this book. From the early settlers who were farmers, to the captains of industries and those involved in law enforcement and a landmark murder case, to leaders in sports and entertainment, they have made Bay Village a home that reaches far and wide.

Our quest began with our first settlers, the Cahoons. They arrived in 1810. Joseph Cahoon and his son Joel were both inventors. Joseph invented a nail-making machine, Joel a machine to make shingles. Ingenuity was the hallmark of the Cahoons. The Osborns arrived in 1811, Sadlers in 1814, Footes in 1815, and Aldriches in 1816. All these families farmed, but they also owned and ran their own mills, fish company, and distilleries. They were all hard workers and left a wonderful legacy for those who came after them. These were the people who set the standards. In turn, our education system has produced the desire to succeed. The question is never are you going to college, but what school are you going to.

Dover Township–Bay Village stayed an agrarian community, prospering through much of the 19th century. The change came with the railroad and the Lakeshore Electric, which opened the area up to become a summer resort village.

—Lee Peterson

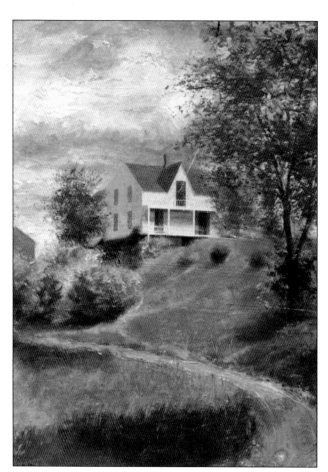

As early as 1799, Joseph Cahoon visited Ohio and wrote a letter to his wife in the East of the beautiful new country he had found. Eleven years later, he and his family made the journey that would give them the distinction of being the first settlers of Dover Township. The picturesque Cahoon home is seen in this painting.

Bay Village is privileged to have historical buildings and homes still standing. This drawing by Marge Gulley shows a composite of these buildings.

One

SETTLERS IN
THE BEGINNING

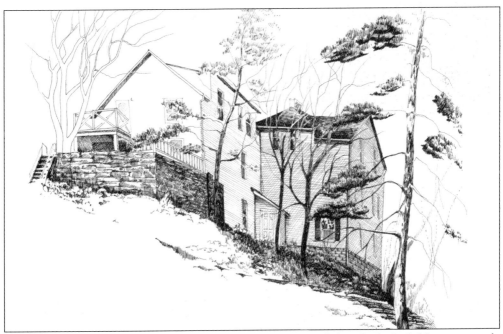

Joseph Cahoon married Lydia Kenyon of Rhode Island, and they had 12 children, primarily born in Salisbury, New York. Their children who lived were Samuel, Amos, Mary, Joel, Abigail, Rebecca, Daniel, Benjamin, William, and Joseph Franklin. In late August 1810, eight members of this family set out for their new home in a wagon pulled by four horses. Joseph and his family arrived on the south shore of Lake Erie on October 10, 1810, and built a log cabin. It took them six weeks to make the journey. This illustration shows the lovely home that they built later and lived in. (Drawing by Marge Gulley.)

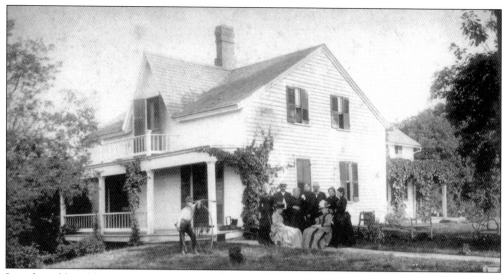

Joseph and his third son, Joel, constructed the house pictured here in 1818. Still standing today, it houses Bay Village's historical society.

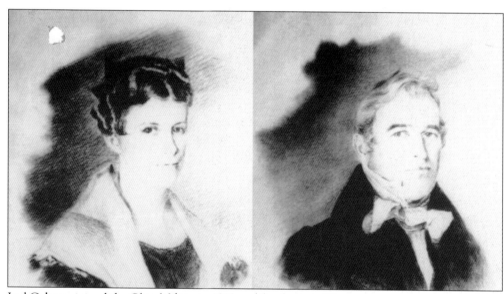

Joel Cahoon joined the Ohio Militia in 1813 and for the next 20 years was a contractor, building canals, aqueducts, viaducts, and railroads in Maryland and Indiana. In 1831, at age 38, Joel married Margaret Dickson Van Allen of Maryland. Her father was in Congress, and she would walk across the lawn of the Capitol on her way to school. She was educated in the best schools and was a refined lady. She and Joel came to Dover Township to live in his father's home, which had been vacant since Joseph's death in 1839. Margaret named the homestead Rose Hill, and she and Joel spent the remainder of their lives there. They had five girls and seven boys.

Rebecca Cahoon was the third daughter of Joseph and Lydia Cahoon. She married Jacob Heath and had a daughter and son.

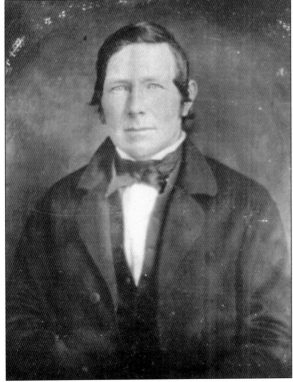

Benjamin Cahoon was the fifth son of Joseph and Lydia Cahoon. He moved away from the farm to Cincinnati and worked for seven years as a stonemason. He then moved to Elyria and married Emiline Hacket, and they had five children.

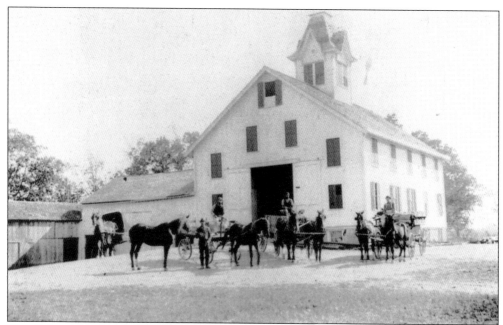

The Cahoons' barn is pictured here with horses and buggies standing out front. In 1882, Joel Cahoon erected this barn south of the house and died that same year at almost 90 years of age.

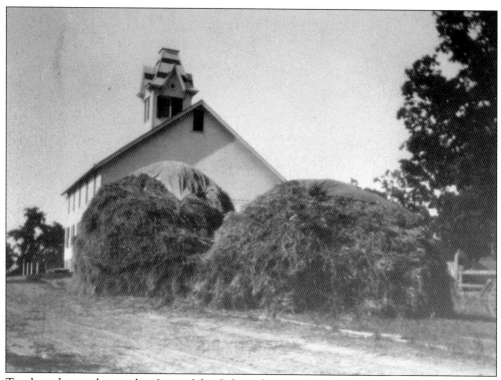

Two large haystacks stand in front of the Cahoon barn in this photograph. There were windows in the barn to provide air circulation so that the hay that had been harvested would not be prone to catching on fire. Notice the wonderful cupola on top of the barn.

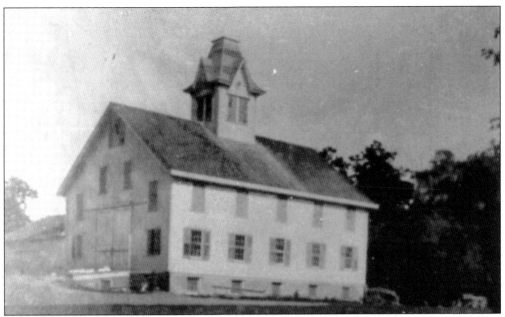

This view shows the west side of the Cahoon barn in the afternoon sunset.

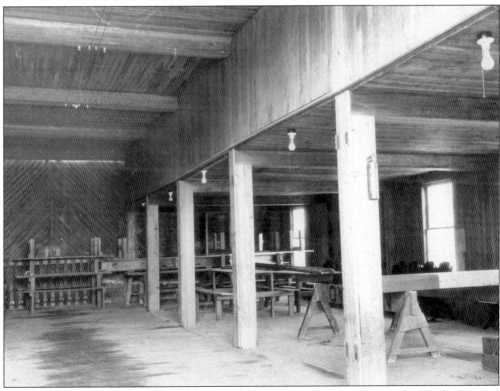

The interior of the Cahoon barn is seen in 1933. During the Depression, the Works Progress Administration remodeled the building into a community meeting space. Today this structure is Bay Village's community house, and residents may rent the remodeled building for various functions.

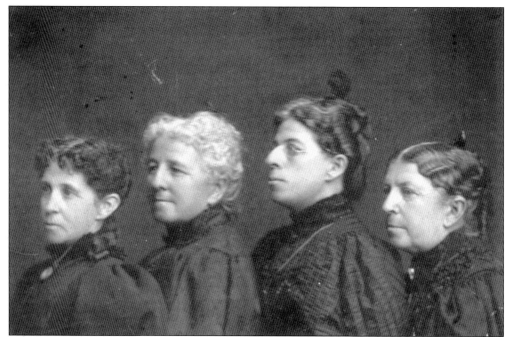

Four of Joel and Margaret Cahoon's daughters are pictured here. From left to right are Martha, Laura, Ida, and Lydia. Ida became the sole heir to the Cahoon property, as her family's will, written in 1883, dictated that the property be left to the oldest survivor.

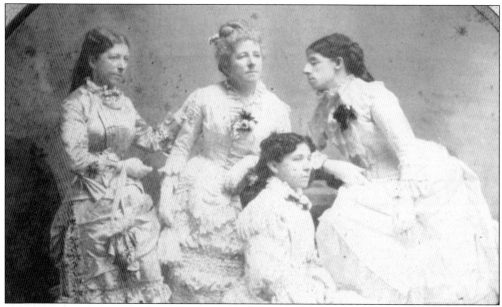

The four Cahoon girls pose in their summer finery. Ida Cahoon and Walter Wright wrote a will that turned the family's property into Cahoon Memorial Park. The will stipulated that the house be a museum or library, that there could be no alcohol in the park, and that no swimming, boating, or organized games could be allowed on Sunday. In 1983, citizens voted to keep the will. It may seem antiquated and inconvenient, but it is a small price to pay for the extraordinary gift bequeathed to the citizens of Bay Village.

14

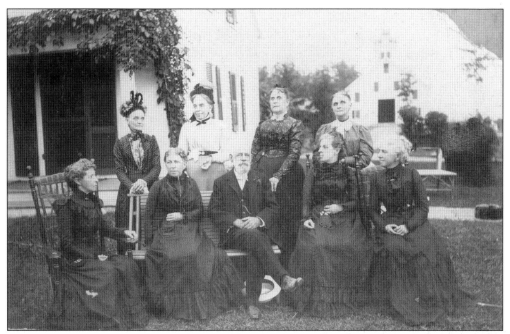

The four Cahoon sisters had their picture taken with their brother and their cousins with the barn and house in the background. The sisters and brother are, from left to right, Martha, Lydia, Thomas, Ida, and Laura. The sisters bought a bolt of black satin, and each of them had a dress made for their photographs.

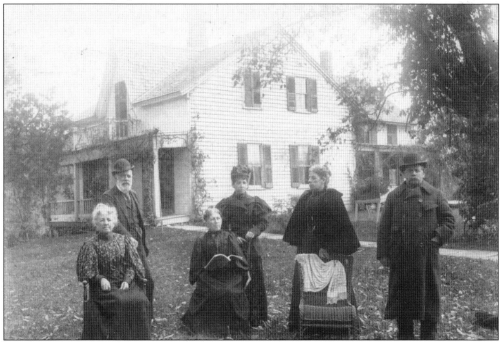

Posing for this photograph outside the Cahoon house are, from left to right, (first row) Laura and Lydia; (second row) Thomas Cahoon and Martha, Ida Cahoon, and John Marshall. An empty chair has been left for Margaret Cahoon, who had passed away.

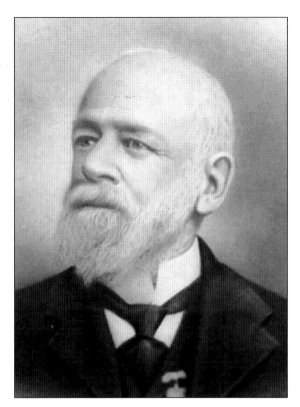

Thomas Cahoon was born in 1832. He was the oldest son of Joel and Margaret. He became a master carpenter and went into the lumber business. He married Elizabeth Hughes of Cleves, and they had one child, Effie.

John Joseph Cahoon was born to Joel and Margaret Cahoon in Frederick, Maryland, in 1834. Early on, he showed evidence of mechanical genius. His inventions were profitable to the cotton industry in the South. He never married, and made his home in Memphis, remaining there until the end of the Civil War. In 1875, he came home to Rose Hill to his loved ones and died there of consumption.

16

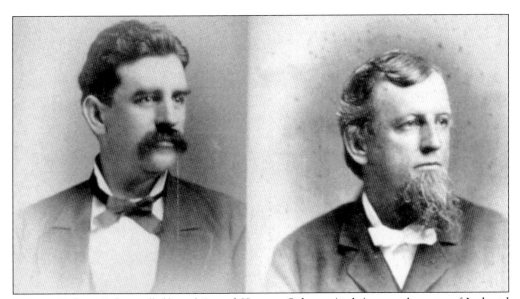

Leverett Judson Cahoon (left) and Daniel Kenyon Cahoon (right) were also sons of Joel and Margaret Cahoon. Leverett Judson was born in Dover Township in 1845, and Daniel Kenyon was born in 1838. There is very little known about Daniel Kenyon except that he never married. In 1863, Leverett Judson was preparing to go to college when his father, Joel, became too ill to work. Leverett Judson instead taught school, managed the Cahoon store, started a fishery, and helped his father with farmwork. He became knowledgeable in viticulture and turned most of their acres into vineyards.

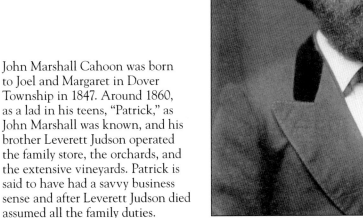

John Marshall Cahoon was born to Joel and Margaret in Dover Township in 1847. Around 1860, as a lad in his teens, "Patrick," as John Marshall was known, and his brother Leverett Judson operated the family store, the orchards, and the extensive vineyards. Patrick is said to have had a savvy business sense and after Leverett Judson died assumed all the family duties.

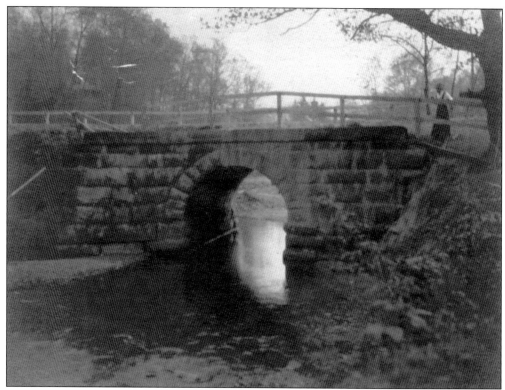

This photograph of the Cahoon property in 1900 was taken looking south from Lake Erie, with Cahoon Creek and the meadow from the north side of the old bridge. The existing Lake Road bridge was not yet built.

This view features the new and old bridges on the Cahoons' property. Almost 200 years ago, Joseph Cahoon proclaimed that "the grassy knoll gently sloping towards the stream and the lake beyond [is] one of the most beautiful spots in America."

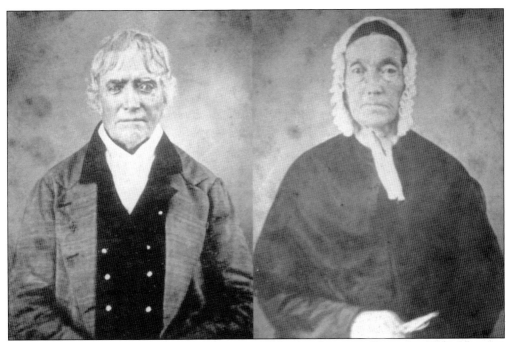

Reuben Osborn was born in 1778, and he married Sarah Johnson in December 1802. He came to Dover Township with his wife's brother in October 1810. They arrived the same day as the Cahoon family. Osborn, however, returned to Camden, New York, until spring.

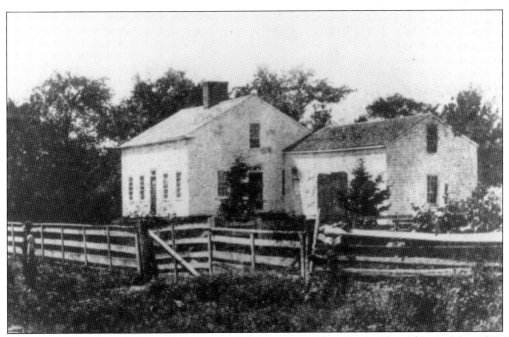

Reuben and Sarah Osborn and their two children returned to Dover Township in May 1811. Soon after arriving, Reuben built a log house. This frame house was built in 1815. Described as a grand new house in its day, it stands today as the oldest frame house between Cleveland and Lorain and is on Cahoon Memorial Park property.

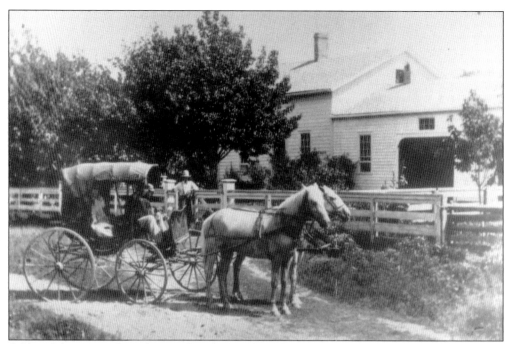

Seldon Osborn was the only son of Reuben and Sarah Osborn. He built his house on the south side of Lake Road in 1832. The house had a gas well and a water tank and is said to have had the first indoor bathroom in the township.

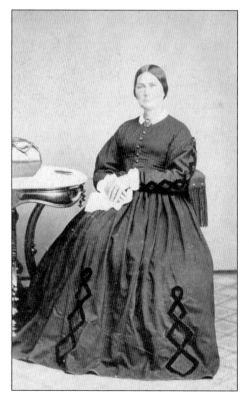

Seldon Osborn married Nancy Ruple, seen here, in 1833, and they had nine children.

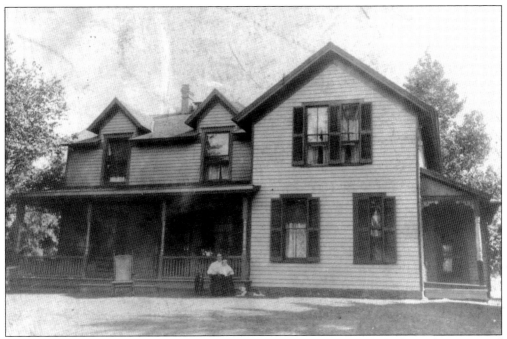

This is Seldon Osborn's house in the late 1800s, which was originally built in the 1830s and remodeled later in the 1800s. Osborn was an herb doctor who received his training in a doctor's office and grew his own herbs.

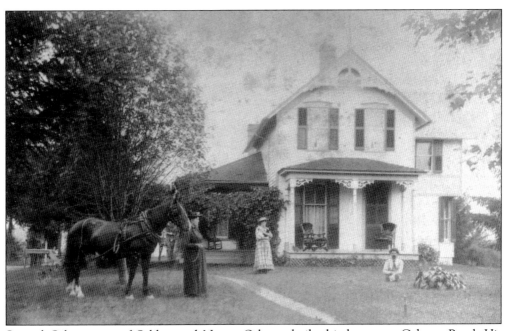

Samuel Osborn, son of Seldon and Nancy Osborn, built this house on Cahoon Road. His grandfather Reuben gave him this property.

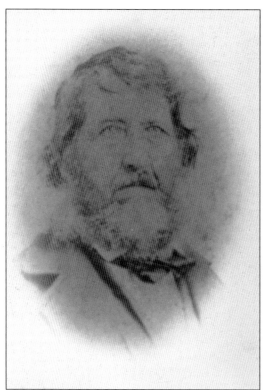

William Sadler I was in the War of 1812 and participated in the Battle of Lake Erie. This brought him to Dover Township. He fell in love with the countryside and contacted the Connecticut Land Company to obtain land. He arrived in the winter of 1814.

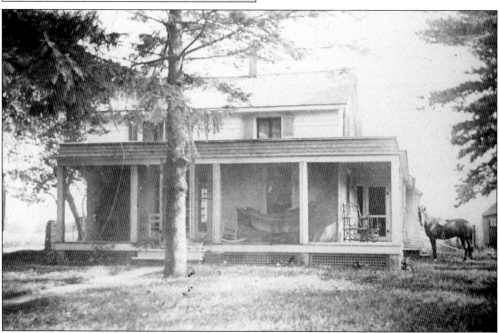

In March 1815, William Sadler I returned to New York to bring his wife, Elizabeth Tryon Sadler, and infant daughter Sophia back to Dover Township. They raised eight children. Only two of the children stayed, William II and Sophia. After living in a log cabin, Elizabeth and William moved into this house.

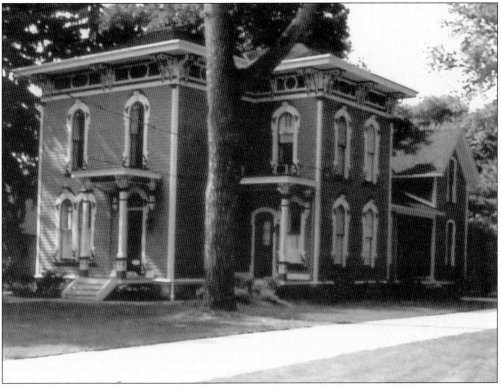

William II built his home on Sadler land west of the original homestead. He was a master craftsman and made all his tools and designed the present structure that won first prize in a house contest in 1876. This home was built for a little over $6,000.

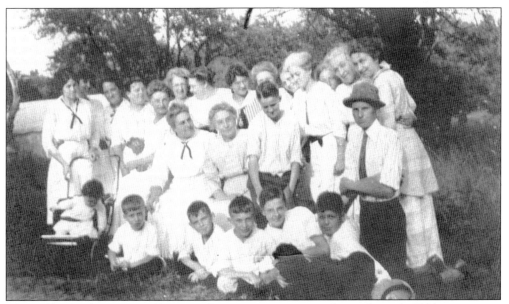

The Sadler family is pictured here out for a picnic on a sunny day in the early 1900s.

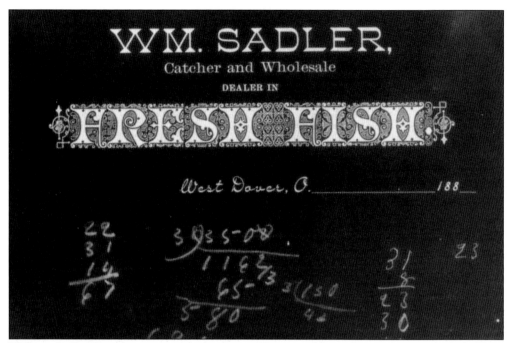

WM. SADLER,
Catcher and Wholesale
DEALER IN
FRESH FISH.

West Dover, O. 188

William Sadler II was an enterprising citizen. He ran a fishery for many years on Lake Erie, harboring his boats directly across from his residence. He not only operated the large farm and his fishing business but was a skilled craftsman.

Eighteen-year-old Burrett Sadler, son of William II and Ann Eliza Sadler, became one of the first councilmen in the hamlet of Bay Village. The election was held on February 18, 1903, for the new hamlet of Bay Village, which had been granted so by the State of Ohio on October 14, 1903.

When David Foote packed up his wife, Betsy, and their family and moved them to Dover Township in 1815, he settled on lot No. 97, which covered the northwest corner of what is now Bay Village, bordering Lake Erie to the north. He built a log cabin using trees from the property. His oldest son, Thomas, helped him construct this log house and cut the trees.

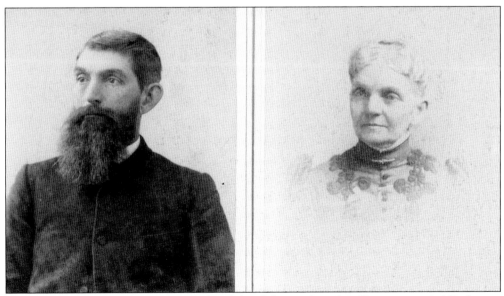

Ranson Foote came to the area in 1815 with his father and mother. Ranson married Catharine Porter, and they had 12 children together. Ranson and Catharine are pictured in this photograph. Sadly, Ranson died at age 43.

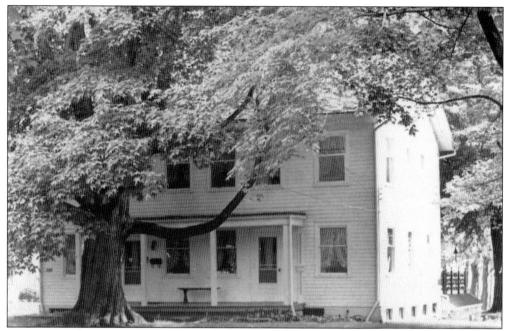

David Foote built this house in 1828, and it was demolished in the 1980s. The Footes ran a sawmill on the cliff behind the main house. It is said that boards were dropped in the lake over the cliff side, then tied together and rafted to Rocky River to sell. Catharine Foote lived here after Ranson's death with her father-in-law. David lived to be 91.

Henry Winsor came to Dover Township in 1817 and lived near his sister Elizabeth Aldrich. His son Henry Winsor II married Martha Cahoon and in 1835 bought property in the township and built his own home, seen here.

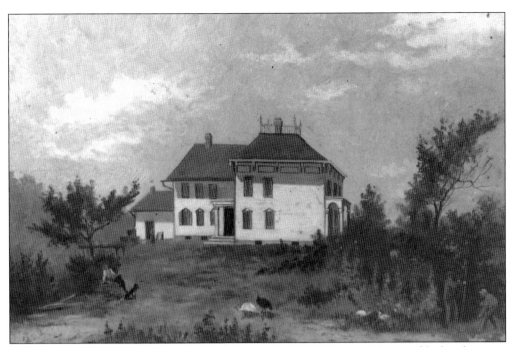

In 1818, John Wolf packed up his family and moved to Ohio. He was 25 years old when he came to Dover Township and settled this 112-acre Bradley Road plot, building a log cabin there. This painting is of the Alfred Wolf house located at Bradley and Wolf Roads.

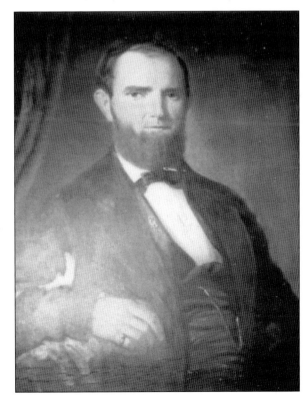

Alfred Wolf, the son of John Wolf, was born in 1828. He served in the Civil War and returned to the family farm in 1862. He was quite a wheeler and dealer and was known around town to carry large amounts of money. In January 1896, he was stopped by a highwayman, robbed, and murdered.

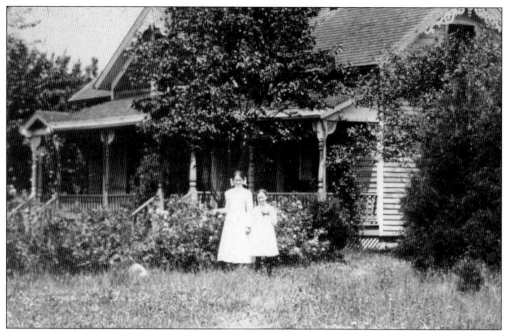

George Wolf, the youngest son of Alfred Wolf and a licensed steam engineer, operated a tugboat out of Cleveland. In his lifetime, he sailed around the world three times. Shortly after his father's death, George came back to farm the 30-acre homestead. In 1903, he raised the roof of the house and built a second story, which can barely be seen in this photograph. His children are standing in front of the house.

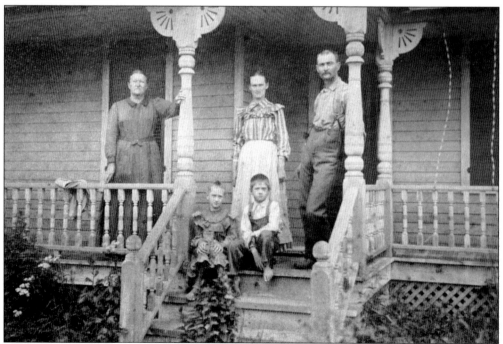

George Wolf, his mother (of the Wischmeyer family), his wife, and his children are seen here on the porch of their home at Bradley Road and Ashton Lane.

In 1816, Aaron Aldrich III and Elizabeth Winsor were married and left Rhode Island to come to Ohio. They lived in Dover Township until 1822 when Aaron took a job in Watertown, New York.

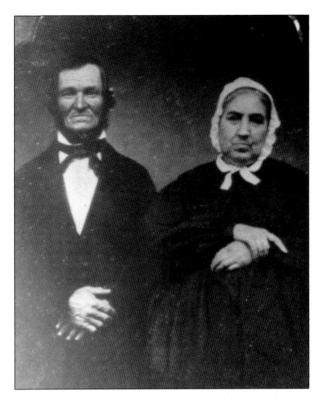

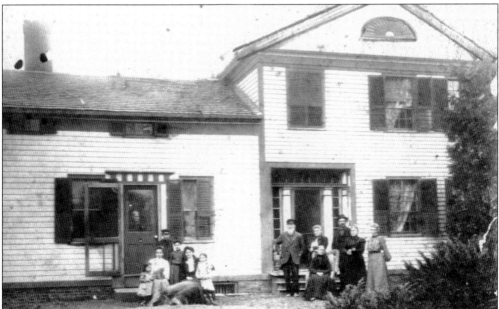

Aaron and Elizabeth Aldrich returned to Dover Township in 1829 with enough income to raise a family of six children and build a home. Aaron paid $500 for 140 acres that extended along Lake Erie running south. They built a log cabin on the north side of Lake Road until this frame house was built on the south side just east of Bradley Road. The taxes on the farm in 1830 were $5.06. The Aldrich and Drake families are seen here.

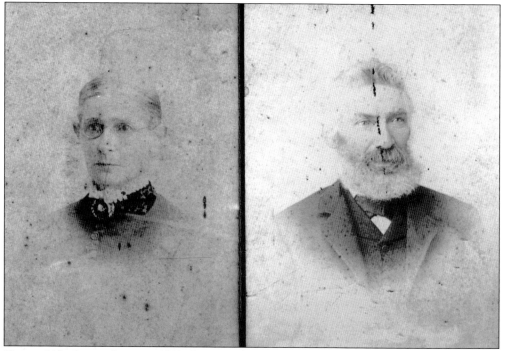

Henry Aldrich was born in 1822. In 1848, he married Mary Ann Stevens. They are both pictured here. Henry was the youngest son of Aaron and Elizabeth Aldrich. He stayed on the farm, buying out the other heirs.

In 1857, William Watermen Aldrich II bought 76 acres and then sold some property to build a house on the remaining acres. In June 1862, he married Janette Bates, and they raised a family of eight. Their home, seen here, still stands on Bassett Road.

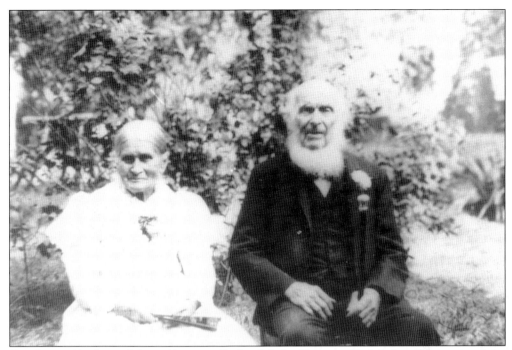

Dr. George Drake and Lucy Eastman Drake (of the Eastman Kodak family) are seen here on their 50th wedding anniversary. Their son Fred married Henry and Mary Ann Aldrich's daughter Della.

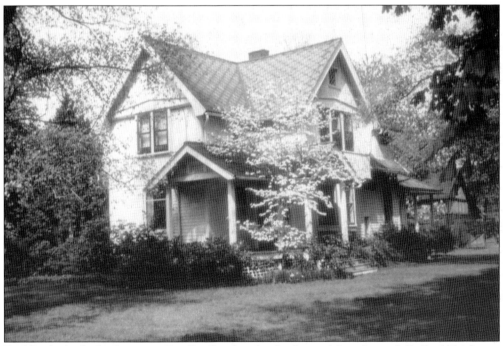

Fred Drake built this house on Bradley Road on land inherited from his wife Della Aldrich.

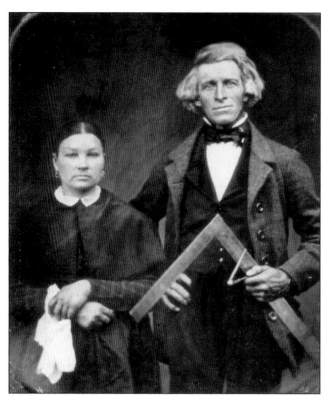

Thomas and Sophie Powell were married in 1832 in Dover Township and had two children. Thomas purchased 80 acres on the west side of Bradley Road and farmed and ran a steam sawmill on the property.

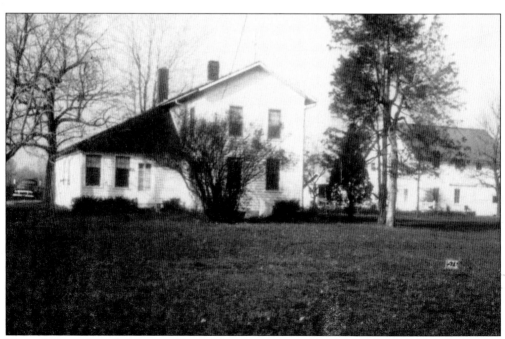

This is Thomas Powell's house and barn. The property stayed in the family until the 20th century.

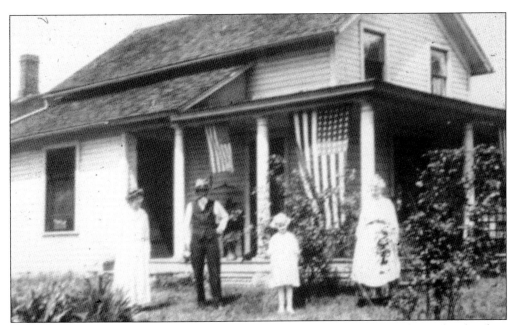

Dexter Tuttle arrived in Dover Township in 1817 and married Amelia Wiedner. They lived on Detroit Road. In 1836, with his wife of eight years, he built a log cabin on the south side of Lake Road, just west of Hall (Columbia) Road. The house sat high on a bluff above the creek, so the view of the lake was grand. He raised sheep and chickens and sold them to the Sliverthorn Hotel. He also had a sawmill, which sold logs and cut lumber.

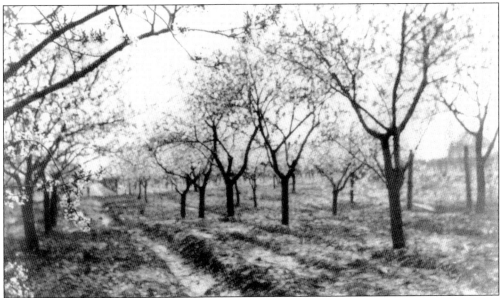

Moses Hall of Lee, Massachusetts, bought 2,100 acres in Dover Township (Bay Village) in 1810 and gave land to his sons and daughters. In 1811, one of his daughters married Nathan Bassett and settled on 50 acres, lot No. 82, which encompassed land from Bassett Road west to Bradley Road and Wolf Road south. This photograph shows Nathan Bassett's orchards. Bassett served as a Dover Township trustee from 1811 until 1839. In 1842, while standing in his barn door, Bassett was struck by lightning and killed.

By 1858, a community of German farmers had made its home in the southwest corner of Dover Township. Grapes were the farmers' predominant crop. The climate along the south shore of Lake Erie was suitable for viticulture, an industry the Germans were familiar with from their homeland. They brought a strict, Old World culture and disciplined lifestyle to the township not seen before. Seen here is the Krumwiede farm. William Krumwiede left Germany in 1847 for Cleveland. He was a very good carpenter and built his own home. He and his sons continued the carpentry trade and built many beautiful houses in Bay Village that are still standing.

Around 1852, Henry and Katherine Hagedorn and their family left Hanover, Germany, for Dover Township. The family purchased 30 acres of land on Bassett Road. The Hagedorn homestead is still standing. Two Hagedorn houses can be seen here on Bassett Road in 1919. The house on the right is the older of the two.

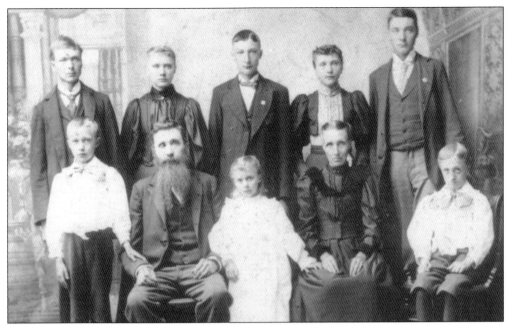

In 1874, Henry and Katherine Hagedorn's son, Fred, along with his wife, Marie, and their children, purchased land on Cahoon Road after renting a cottage from the Cahoon family. Their house had many additions, as the family grew to eight children. At one time in the 1930s, within 400 feet of one another, five male Hagedorns and four female Hagedorns made their homes along Bassett Road, as noted in *Ripley's Believe It or Not!*

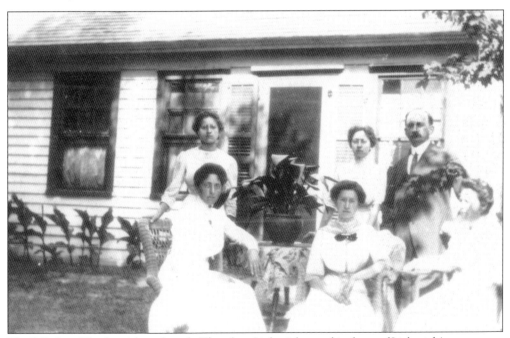

The J. Robert Hassler girls and uncle Theodore Lieberich stand in front of Lieberich's cottage on Bassett Road. Lieberich purchased land near Hassler and built this cottage, which everyone shared until the big new house was built and the cottage was moved to the back of the property.

Frank Meilander's farmhouse on Bassett Road is pictured here. In the 1860s, J. Heinrich Meilander purchased 75 acres on the west side of Bradley Road. Heinrich had four sons and three daughters.

John Meilander Jr.'s farmhouse was located on Bradley Road. Sons Frank and Henry both purchased land on Bassett Road. Two of their houses and one barn are still standing.

Here is Henry Meilander's farmhouse on Bassett Road. Meilander purchased his property from William Waterman Aldrich I.

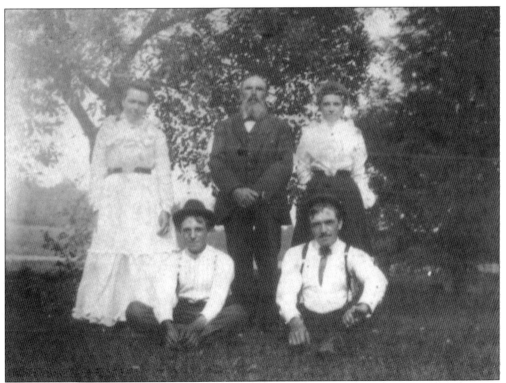

This is the Toensing family. In 1867, Jobst and Marie Toensing purchased 20 acres of land on Bradley Road and raised a family of five. Their children were Carrie, Jobst, Lena, William, and John.

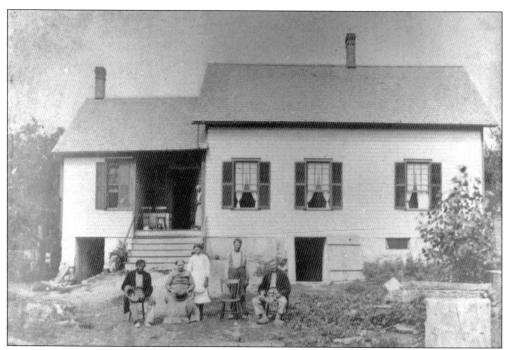

The Koch farm is seen here. Christian Koch purchased his property on Walker Road. He is listed in the census as a farmer who produced grapes, corn, hay, wheat, potatoes, berries, and apples.

Henry Koch, Christian Koch's only son, inherited the farm and raised his family there. He added a second floor to the house. Henry was a Bay Village councilman and his son, Walter, was a Bay Village fire chief. Henry Koch and his family are seen here.

The Starke family farm is pictured here. They did landscape gardening in the area, and their property was always immaculate. Some of the acreage was planted with chrysanthemums, which went to market.

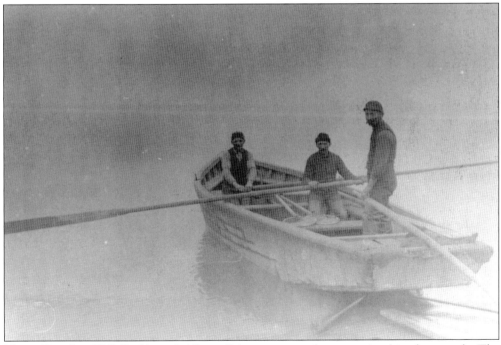

Henry Davider, Will Dodd, and Albert Osborn are out for a row in this photograph. The Daviders grew peach and apple trees, grapes, and berries. Henry Davider was known for his carpentry skills.

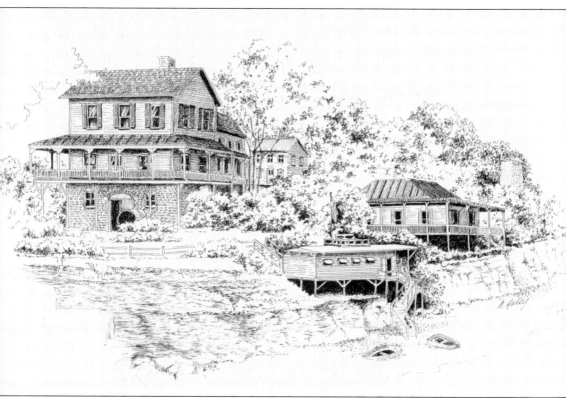

In 1874, the Wischmeyers built a resort hotel that could accommodate 70 guests. They also built a clubhouse and a boathouse near the beach. The hotel became a regular stop for businessmen traveling from Sandusky to Cleveland. (Drawing by Marge Gulley.)

Henry Wischmeyer Sr. immigrated to Dover Township in 1872. After many years of hard work, he had enough money to purchase lot No. 96 in Dover Township. After a day's work at his job in Ohio City, Henry, his wife, Regina Catherine, and their children, Louis, Henry, Julius, Adelheid, Mathilda, and Olga, would travel to Dover Township to work on their land. Henry started by planting two acres of grapes. These small vines grew and matured, and Henry soon had his first crop. He eventually moved the family to Dover Township to live on their property.

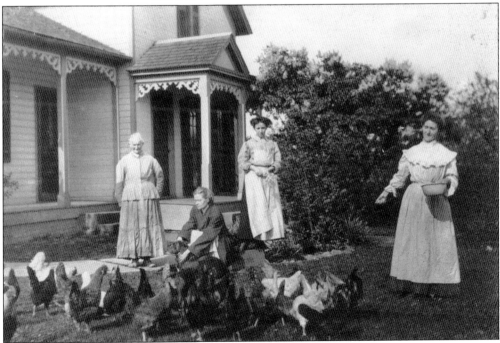

On the south side of Lake Road, across from the Wischmeyer Hotel and wine cellar, the family lived in a small house known as "Granny's house." Henry Wischmeyer's mother, Regina Catherine "Granny" Wischmeyer, and her granddaughters are seen here feeding the chickens.

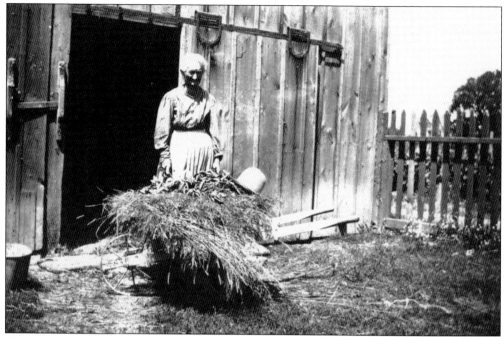

No one worked harder than Granny Wischmeyer. She cleaned the stalls and picked grapes in the vineyards.

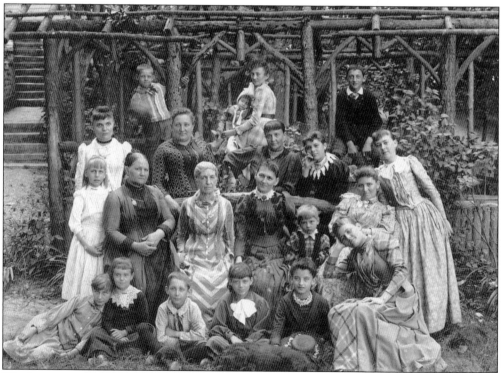

Wischmeyer and her family and friends are gathered here for a photograph.

One of the Wischmeyer girls is seen in this photograph in a very romantic pose.

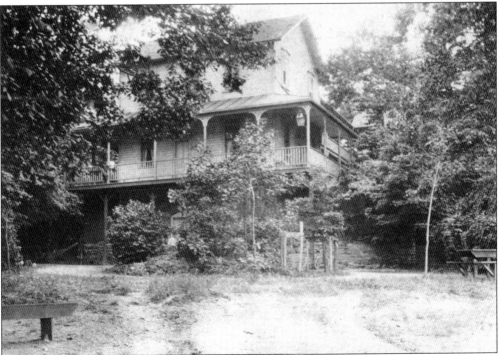

This photograph shows another view of the popular Wischmeyer Hotel, which sat on the north side of Lake Road overlooking Lake Erie.

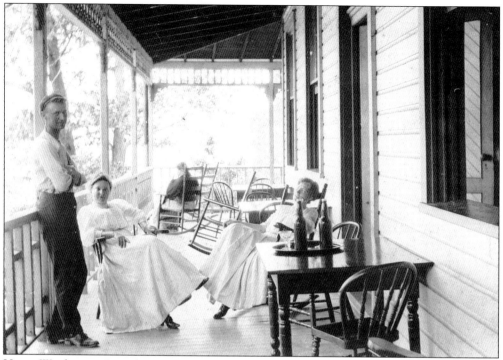

Henry Wischmeyer Jr. and visitors sit on the front porch of the hotel in this photograph. Visitors were attracted to the porch for the cool lake breeze.

This spry young fellow's name is Ritchie. The photograph comes from the Wischmeyer photo album, so he may be either a Wischmeyer family member or a hotel guest.

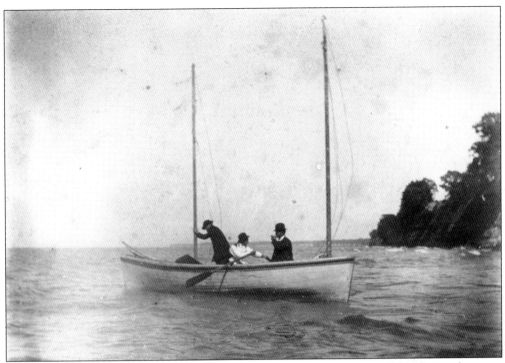

These men, who were Wischmeyer Hotel guests, are dressed in suits and bowlers and getting their boat ready to sail. Notice that it has two masts.

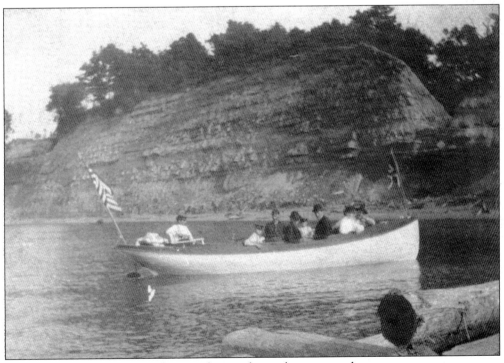

These Wischmeyer guests are leaving the pier for a ride in a motorboat.

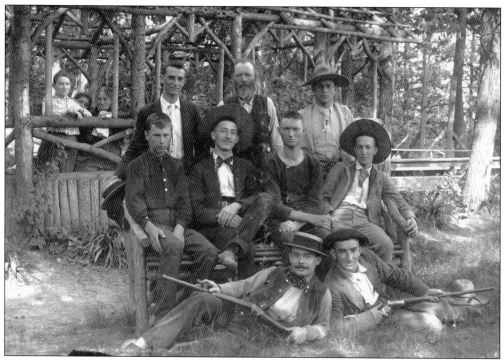

Family and visitors enjoyed all the hotel had to offer. Here are visitors and Henry Sr., Henry Jr., Julius, and Louis posing under the hand-cut trellises made by the Wischmeyers from the abundance of wood on the property.

The Wischmeyer girls and their brother have their photograph taken on the pier.

This is one of the Wischmeyer houses on the family's property on Lake Erie with two of the girls pictured.

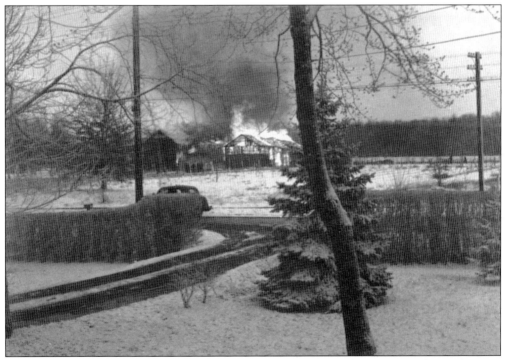

One cold, dark night in the 1940s, the Wischmeyer barn burned down. Rumor has it that two young boys were seen smoking in the area.

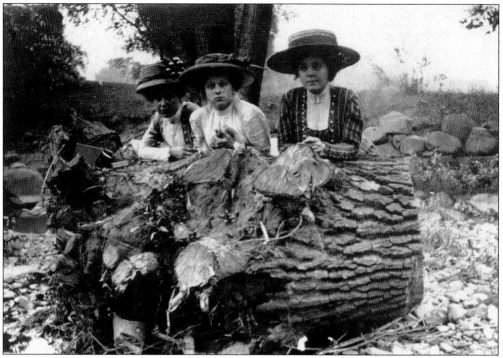

These Wischmeyer Hotel guests pose for a photograph in the woods.

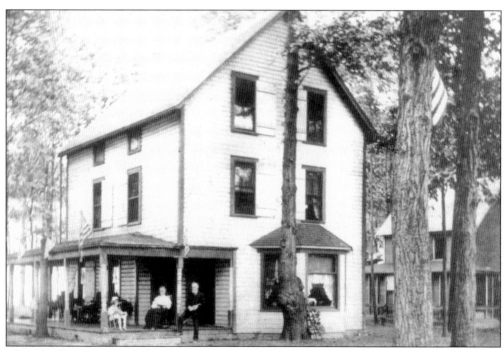

The Charles Stone family lived on Lake Road in one of Bay Villlage's first subdivisions. The property ran along the lake. There is still an easement between the back of the houses and the lake for a park.

Two

DOING BUSINESS

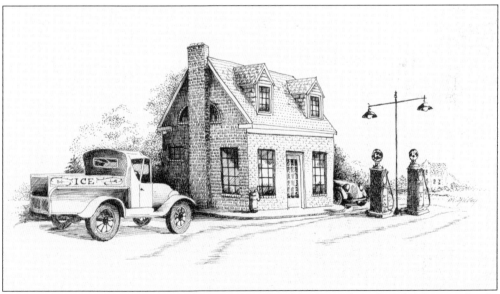

The gas station on the corner of Dover Center Road and Wolf Road was built by the Bott family. For many years, it was known as Olchen's, as Ernie Olchen was the proprietor. It is still a garage today but without gas pumps. (Drawing by Marge Gulley.)

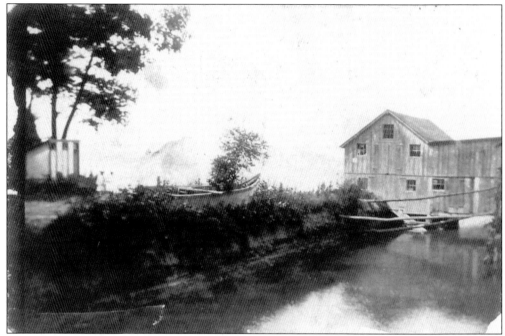

To supplement their farm income, the Cahoons built a fish house at the mouth of Cahoon Creek. In the late 1800s, it was leased to the Buckeye Fish Company.

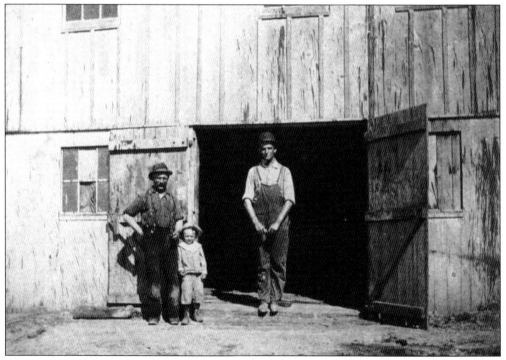

The manager of the Buckeye Fish Company and his helper are seen here standing in the doorway. "The men who catch the good fish," remarked a Wischmeyer Hotel guest.

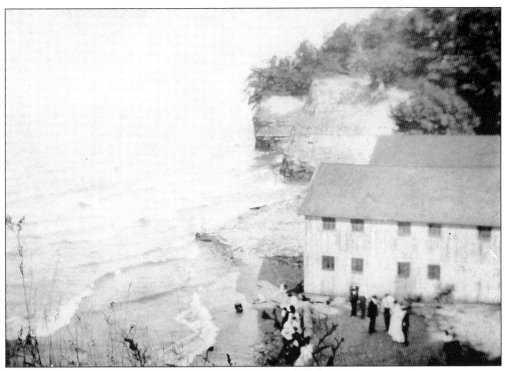

This view shows the Buckeye Fish Company from the cliff above.

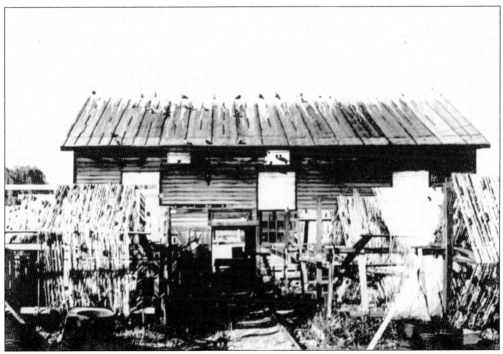

Fishnets are being dried on racks at the Wischmeyers'. If the fish was not edible, it was sold as fertilizer for the fields.

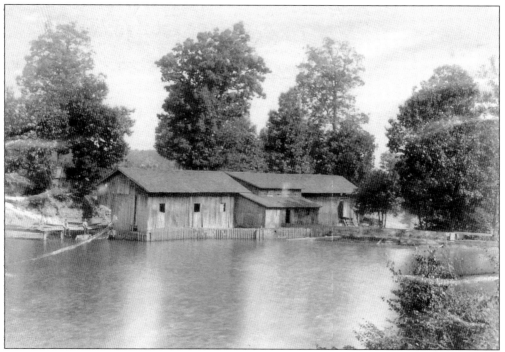

This view of the old Oviatt mill and pond on the east bank of the creek shows the spillway on the right. The large millpond ran to the New York Central Railroad tracks. Milling was a big part of the community. The Cahoons, Clemens, Peters, Wischmeyers, Footes, Wolfs, and Oviatts all had sawmills on their properties, sometimes on the same creek.

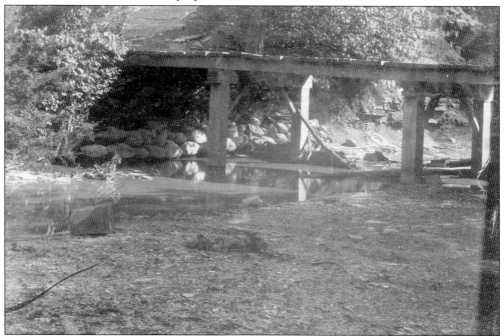

The wooden bridge over Cahoon Creek, between Cahoon Road and the Oviatt sawmill, is pictured here in the 1890s.

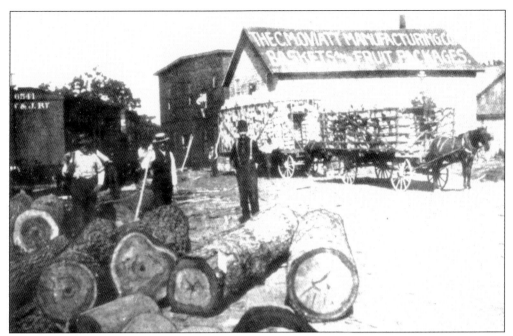

The Oviatts built a sawmill, running north of the Oviatt Bridge. They stayed in the basket-making business until the 1920s. Many of the trees cut were black walnut. The last black walnut tree in the area stood in the parking lot of the Methodist church. Note Zipp Manufacturing in the rear.

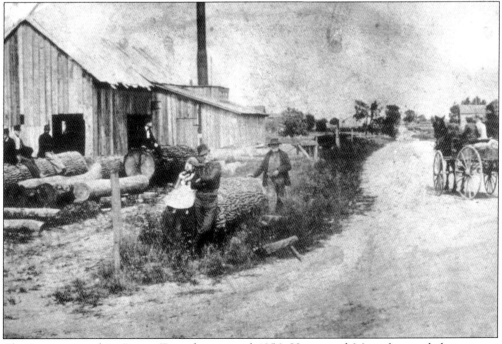

The Peters arrived in Dover Township around 1856. Henry and Marie baptized their son at the Lutheran church on September 7, 1856. They built their home at the northwest corner of Bradley and Nagle Roads and operated a steam mill on the property seen here.

In 1927, Bay Village was given its first post office, located on Dover Road. It was a small wooden building the size of a double garage.

In 1815, Asahel Porter was the first settler in the township to serve as postmaster. Reuben Osborn became postmaster in 1820. Michlich's Sundry Store also served as a post office on Dover Center Road. Mail was delivered with just a name, city or township, and state written as the address. If written in German, it still made it to its destination.

Ernie Wuebker was North Dover Township's first rural mailman. He worked out of the West Dover Post Office in Gus Fortlage's house on Bradley Road. In 1904, Fortlage received a contract to start the first rural mail route and suggested Wuebker, his neighbor to the north, be the mailman at $50 a month. Orville Bently became postmaster in 1936.

The first postmaster was appointed for three years. In 1966, the job of postmaster was discontinued and was replaced with supervisors, and later managers.

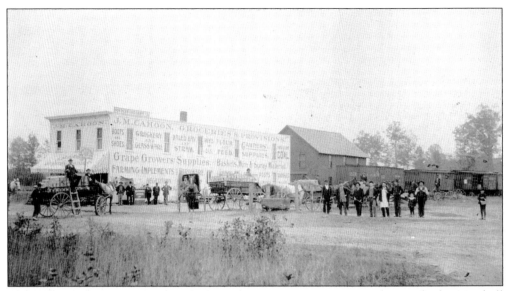

The Cahoon Store is seen here in the late 1860s. Teenagers Leverett Judson and John Marshall Cahoon had the responsibility of operating the store, which was across from the Oviatt sawmill. The building housed groceries owned by the Cahoons, Wischmeyers, Blahas, Sylvesters, and Clausens before it was torn down. In 1882, the New York Central Railroad approached the family about leasing land to lay track for a new railroad bed. The family decided that they would lease the adjoining property if a train station was erected on the site. The New York Central agreed.

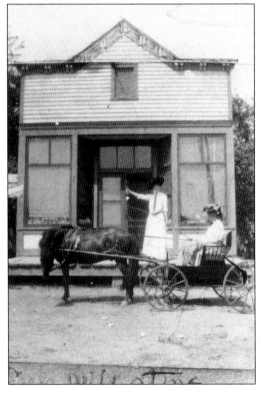

This small grocery store was owned by George Pecarik and was on Bradley Road at stop No. 35 next to the Lake Shore Electric tracks. It offered shelter during bad weather and everyday needs such as bread and milk. Catharine Foote (in the buggy) and a Mrs. Balsger are pictured in front of the store around 1903.

A Mr. Pencik built the West Shore Supply Company in 1919 on Bassett Road. It was next to the Lake Shore Electric Railway tracks, and passengers purchased groceries and waited for the trolley. During the Depression, it changed hands and was leased to the A&P chain. When the interurban shut down in 1938, so did the A&P.

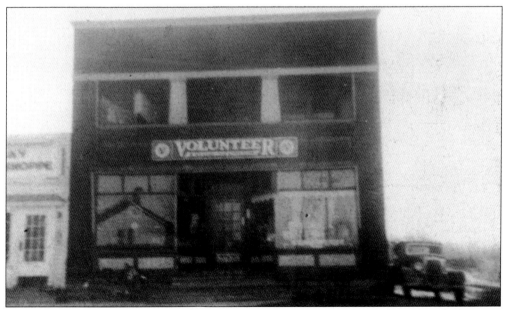

The store reopened as a mom-and-pop store run by George and Martha Schmidt. It was a cooperative store called the Volunteer Store. To the left was a sweets shop run by the Serb brothers, George and Bob.

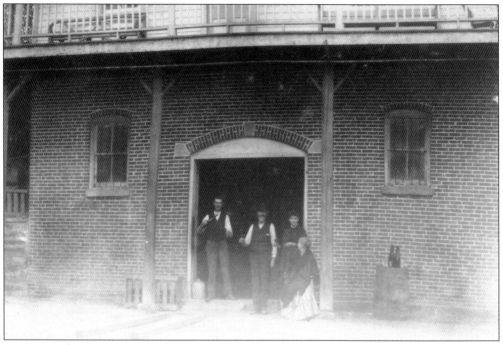

Henry Wischmeyer Jr. is seen here, on the right, with one of his helpers, his daughter, and Granny in the wine cellar that was located beneath the Wischmeyer Hotel. The cellar could store 10,000 gallons of wine.

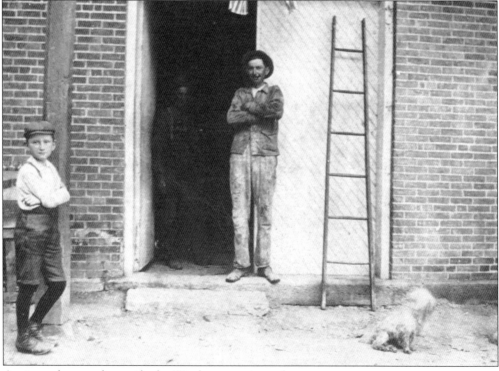

A winemaker stands outside the Wischmeyer winery door.

Regina and Henry Wischmeyer Sr. (on the left) stand in their vineyard. Notice the water tower and smokestack in the background.

Here Wischmeyer girls Olga and Matilda pose among the grapevines.

Granny Wischmeyer, with her daughters, sits in the cart coming from the vineyards.

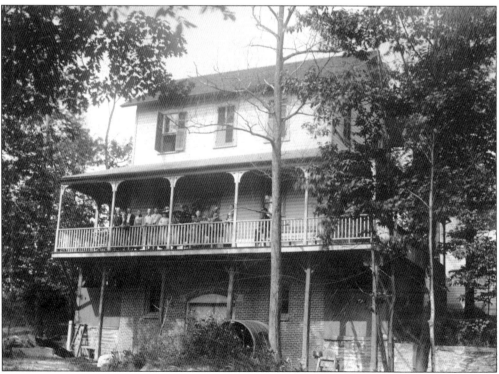

The Wischmeyer Hotel was built above the winery. It had enough rooms to house 70 guests.

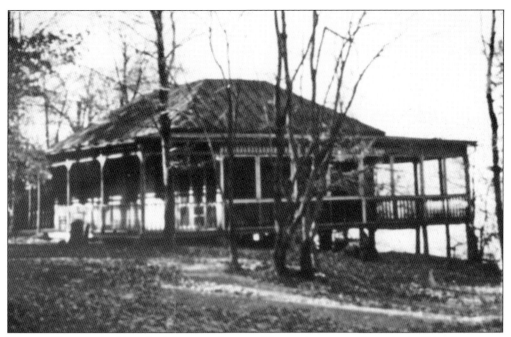

The pavilion overlooking the lake was often used for card games and parties held by the guests. On weekends in 1919, Daniel F. Marsalek, whose family still resides in Bay Village, came from Cleveland to play the piano in the dance hall. Marsalek said the hall was shut down after a man was murdered there in the late 1920s.

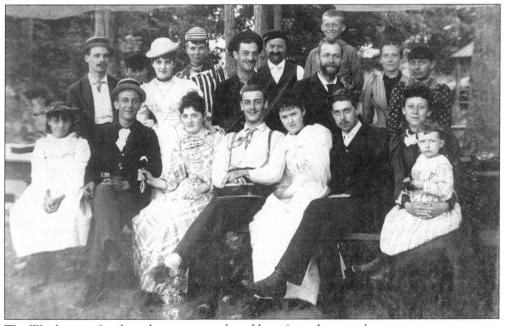

The Wischmeyer family and guests are gathered here for a photograph.

The Wischmeyer family kept chickens for eggs and cows for milk. Everyone in the family had a job. The girls did the cooking, cleaning, waitressing, and bed making. The boys took care of the heavy chores. Henry Jr., Julius, and Olga are seen here.

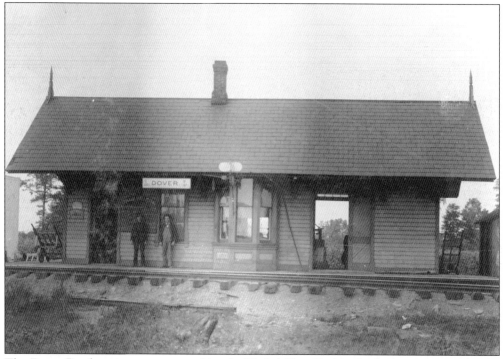

The Dover Road station was operated by the Nickel Plate Railroad, which was owned by the New York Central Railroad.

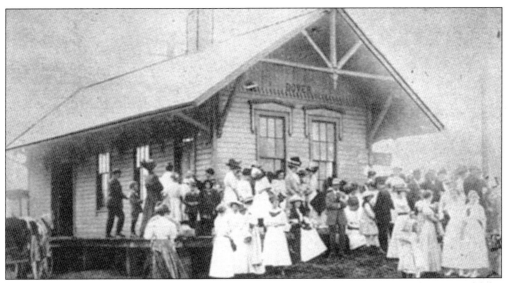

This crowd gathers at the Dover Road train station for a ride to a picnic grove. (Courtesy of the Porter Library.)

Vivian Lyndon Peterson (right) and his family are in this photograph. Peterson was the stationmaster at the Dover Road train station in the 1920s and 1930s.

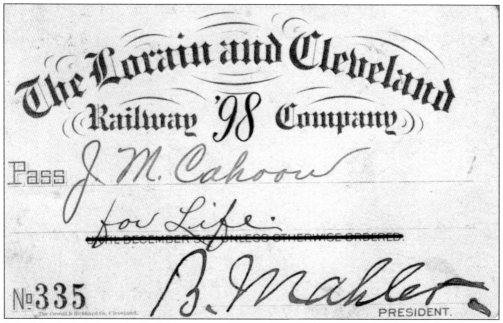

John Marshall Cahoon had a lifelong train pass.

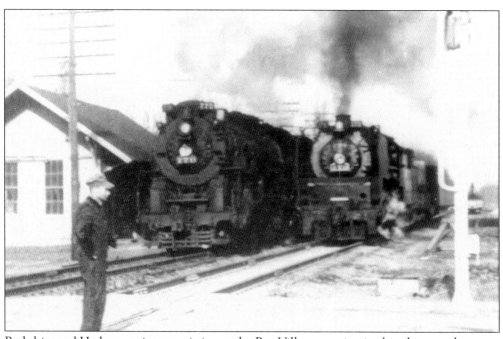

Berkshire and Hudson engines are sitting at the Bay Village crossing in this photograph.

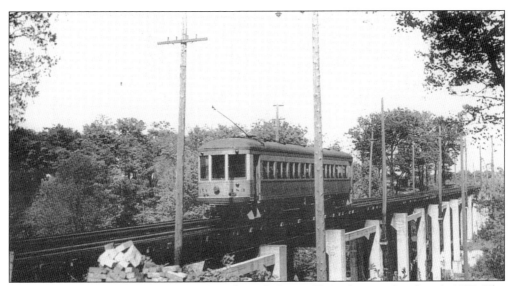

The Lakeshore Electric began operation through Dover Township on October 6, 1897. The maroon car rolled west on private tracks, which were owned by a group of investors from Cleveland. This car is traveling over the Huntington trestle where the right-of-ways were 40 to 60 feet with 70-pound rail spikes attached to oak ties.

The substation on Clague Road was 13 miles from Cleveland and 116 miles from Toledo.

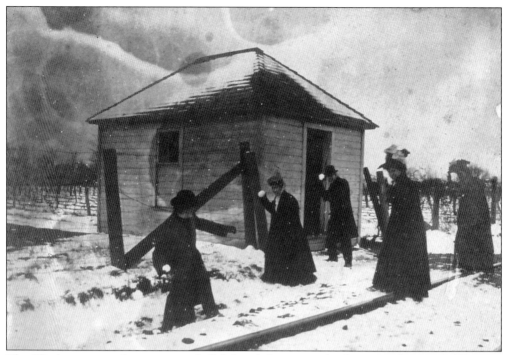

The Wischmeyers are having a snowball fight while waiting for the interurban train. This was their personal shelter built to keep the hotel guests out of inclement weather.

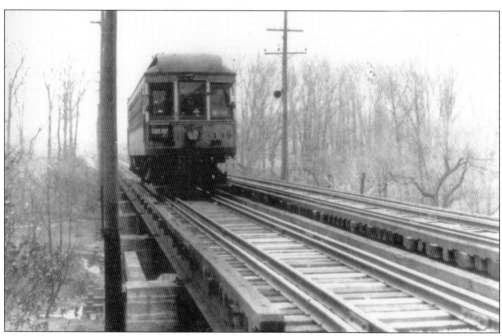

The Cahoon trestle is seen here on July 4, 1926, as a group of picnickers waits for the interurban at Dover Road. Six of the riders decided to walk back west to the next stop to get a better seat. While they were on the Cahoon trestle, they were struck and killed by an eastbound car. Their bodies fell into the valley below.

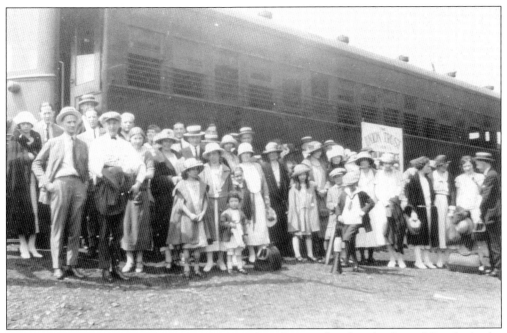

A group of Union Trust employees is waiting to board a train heading for Crystal Beach. At the far left are Alberta and J. Ross Rothaermel. They were longtime residents of Bay Village, and it was their twin daughters who wrote the village's first history, *Bay Village, A Way of Life*.

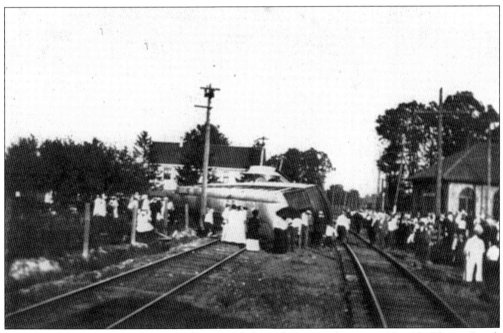

This photograph is an up-close and personal shot of the wreck at stop No. 13, Clague Road, in 1912.

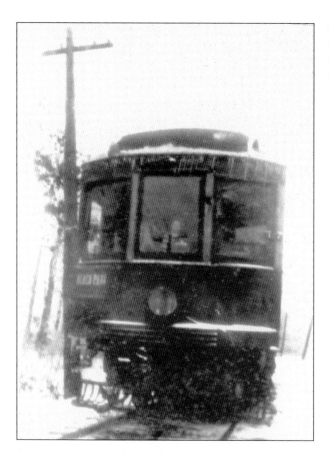

This photograph of Sally Irwin Price was snapped by her sister, Lois. Price is playing motorman and can be seen in the car window.

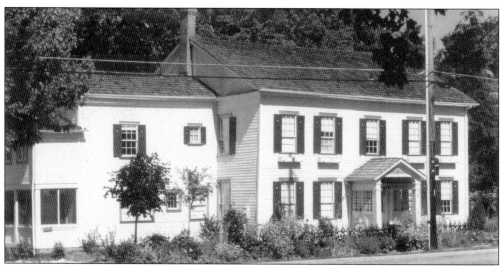

In 1910, the Ellenwood family purchased this house from the Cahoon family and rejuvenated the house and the grounds. They had tennis courts built on the south side of Lake Road. Mrs. Ellenwood loved to work in her extensive gardens, and they were well known. The house was originally built by Eliphalep (Eli) Johnson in 1830 and sold to J. Baker in 1845. He was the first minister of the Methodist church.

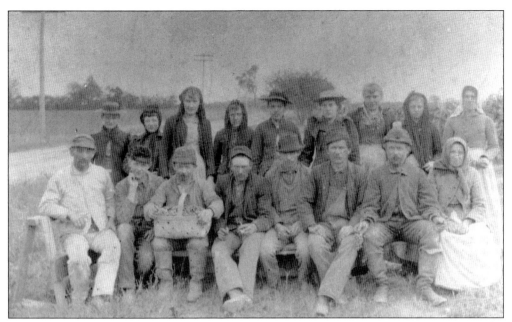

These migrant workers at the Cahoon vineyards were housed in the Baker-Hassler house. The Cahoons bought the property to the west of their vineyards in the late 1800s to house their migrant workers during grape-picking season and called it Castle Garden. The name Castle Garden came from an establishment of the same name in New York City that housed immigrants before Ellis Island.

Mrs. Ellenwood made the property a showplace for North Dover. C. Ellenwood built the Westlake Hotel in Rocky River and was very successful. The Ellenwoods traveled extensively in Europe. Rose Hill Museum has a beautiful brown satin suit dress with enameled buttons that was purchased by Mrs. Ellenwood while in London.

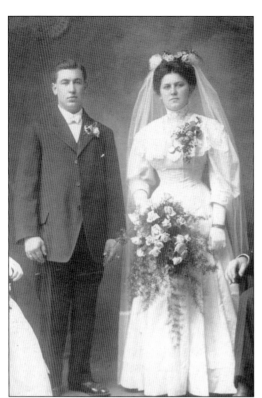

William Blaha and Mary Januska are pictured here on their wedding day in 1908.

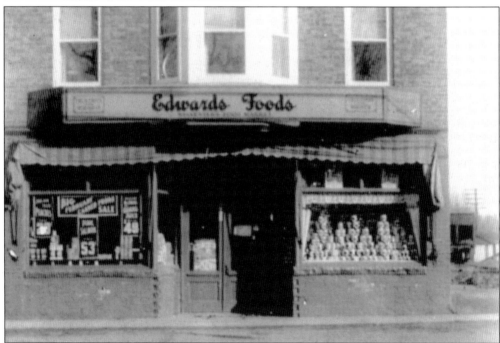

In 1914, William Blaha was operating a grocery in Cleveland on East Sixty-fifth Street when Edwards Foods approached him to take over a store in Bay Village. The store had originally been the Cahoon Store.

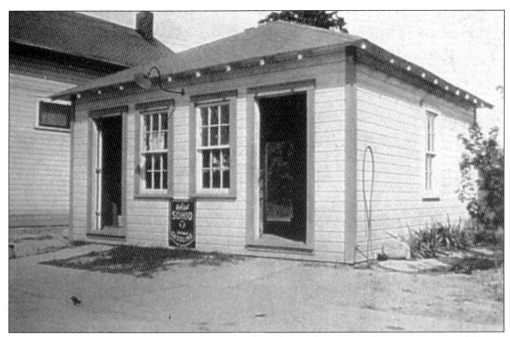

William Blaha purchased land north of the Edwards Foods store at the intersection of Oviatt and Dover Roads. The first building that he constructed was a gas station. Sohio boasted that it had a dot on its Ohio state road map for every township with a pump, but it missed Bay Village. Blaha made sure that the next map it printed had a dot locating Bay Village.

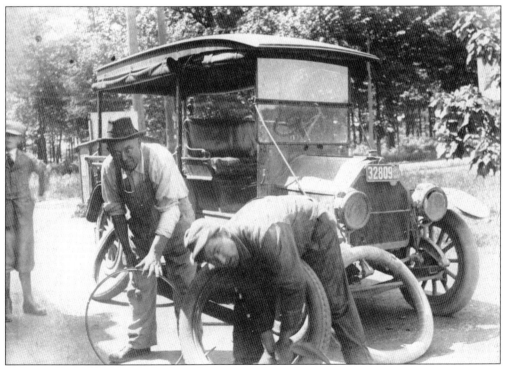

Blaha and his father-in-law, Joe Januska, are seen here changing a tire.

William Blaha Jr. sits in his car in front of the gas station showing two Sohio pumps.

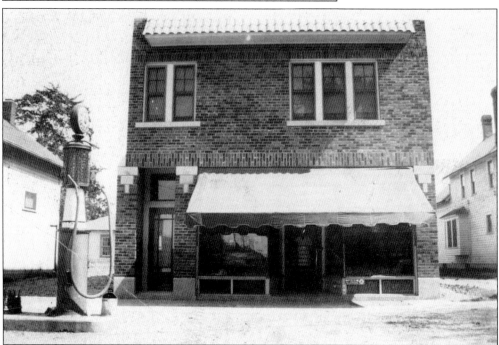

William Blaha built a new brick building in 1929. The grocery–meat market was on the first floor, and a three-bedroom, one-bathroom apartment was upstairs. The Blahas raised four girls and one boy in this apartment.

Marie Blaha Peterson opened her beauty shop in what was slated to be the meat market after graduating from Parkview High School in 1927.

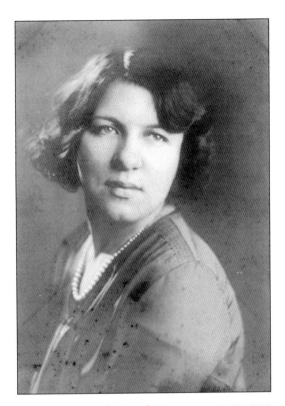

Peterson's beauty parlor will celebrate 80 years in business in June 2007. The longest continuing business in Bay Village, it is now housed in the brick building next door. It is still owned by the family, and there have been five generations of this family living in Bay Village.

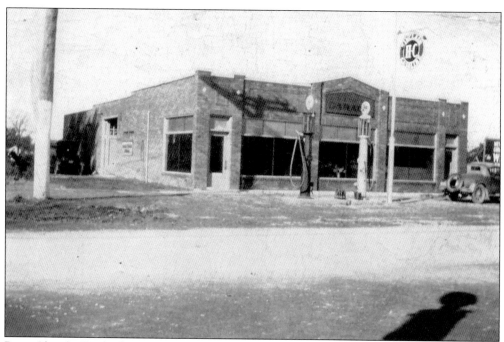

Botts Chrysler Dealership sat on the northwest corner of Dover and West Oviatt Roads. Notice the two gas pumps out front and also, across the street, the shadow of the pumps in front of William Blaha's store.

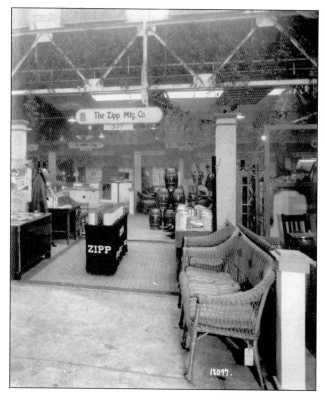

A John Zipp came to Bay Village from Cleveland to make his syrups in the 1920s. His company supplied customers with ginger beer, root beer, fruit syrups, and chocolate syrups. The company was located on west side of Dover Road across from the train station. This photograph shows the lobby of Zipp Manufacturing, which operated until the mid-1990s.

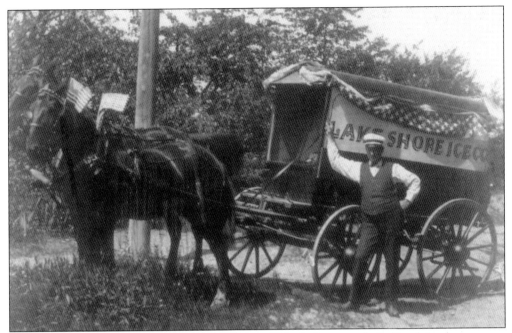

Julius "Papa" Serb's ice business was located near Hahn's Grove on Lake Road. In the summer, the children followed the wagon hoping for a piece of chipped ice to come loose and fall off. If one was lucky, the iceman would throw a piece.

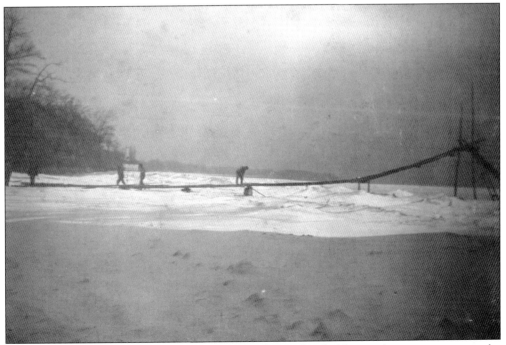

These men are cutting ice at the mouth of Cahoon Creek. Notice the water tower at the Huntington summer cottage in the background and also the curve in the shoreline that forms the bay.

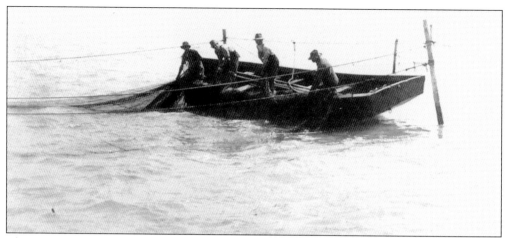

These four men are pulling in the day's catch with a large net.

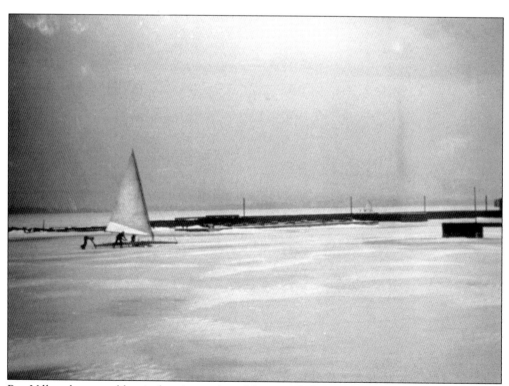

Bay Village boys would go iceboating and ice fishing on Lake Erie in the winter months.

Three

THE LAWRENCES AND HUNTINGTONS

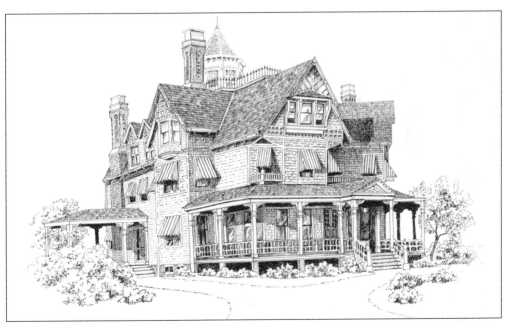

The John Huntington summer home is pictured here. After purchasing the land, Huntington built this country estate on the north side of Lake Road, overlooking Lake Erie. Its water tower was on the north side, and on the south side were the barn and caretaker's houses. The Huntingtons' house burned down in the 1920s. (Drawing by Marge Gulley.)

Because the cities were so crowded and polluted, many very affluent people looked for a healthy and secure place to summer during the intense heat. Dover Bay Colony was such a place in the 1870s. The large frame clubhouse was built in 1874 along with the cottages. The golf course was located on the south side of Lake Road, and the clubhouse, with its winding circular driveway, was on the north side and was heated in the winter months by the powerhouse.

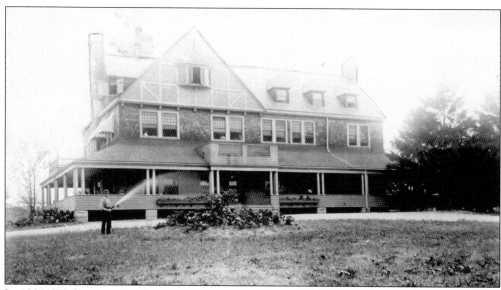

In 1880, Washington Lawrence came into possession of Dover Bay Colony and improved the grounds. He built a clubhouse, which was completed in 1889 at the cost of $430,000. Several prominent citizens of Cleveland erected cottages on the park grounds and moved there in the summer of 1892. Among the most elegant and costly are those of J. Perkins, M. A. Hanna, O. B. Rhodes, W. J. White, and Byron Harris. Some of the land was rented out to people who later built their own cottages. (Courtesy of the Porter Library.)

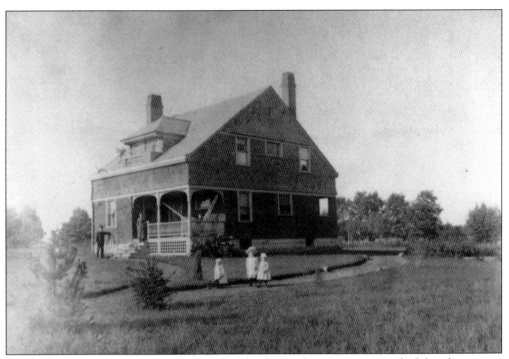

As the Lawrence daughters married, they lived either in the mansion or in the lakeside cottages situated around their parents' home. The Bemis cottage is pictured here in the early 1900s.

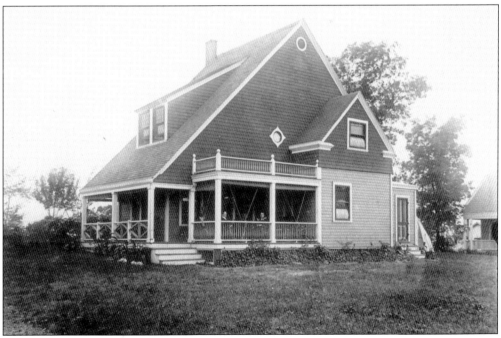

This is the family cottage of Myron Herrick. No one lived in the cottages during the winter, until 1918 when heating systems were installed.

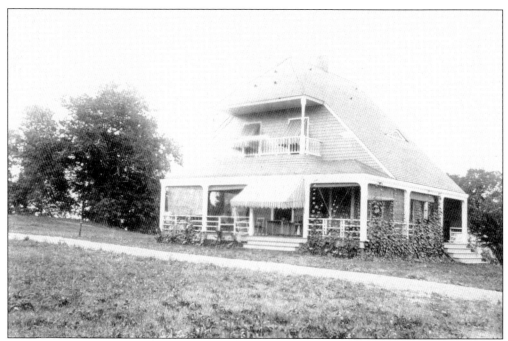

Kenneth Ingersoll was married to Winifred Lawrence Ingersoll, one of Washington Lawrence's daughters. This was their cottage.

The Dodge summer home is pictured here.

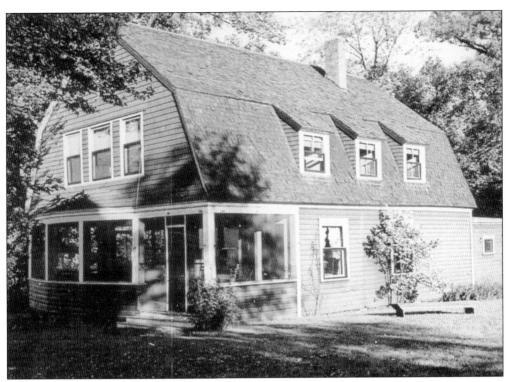

Carl Fuller's cottage home was built much later.

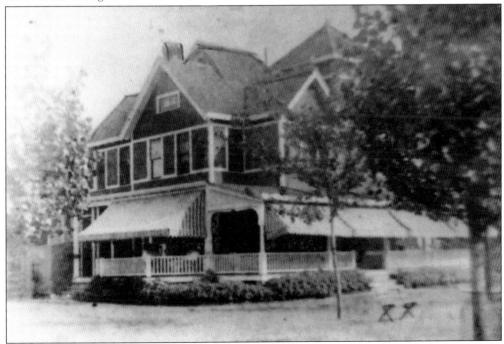

This cottage sat on the east hilltop and was renovated for the Lawrences' daughter Irene Lawrence Fuller and given to her as a wedding present. It is still referred to as the Fuller house. This house was destined to be in worldwide news several times in its lifetime.

Lawrence and Irene Fuller relax on the front porch of their home.

Washington Lawrence attended Baldwin University, now Baldwin-Wallace College, in Berea. He married Harriet Collister in 1863 and had seven daughters. Lawrence became an associate of Charles Brush, the inventor of the arc light, which in 1879 first lit Cleveland's public square. It was the first city in America to be lit with electricity. By 1886, National Carbon (now known as Union Carbide) was founded. Lawrence joined the company in the late 1800s and was president until his death in 1900. Lawrence and his wife, Harriet, are pictured here.

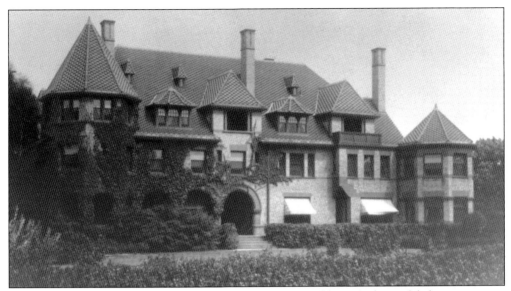

The Lawrence mansion contained three sitting rooms, a library, a beautiful dining room, a kitchen, and a massive hall and stairway that led to eight bedrooms on the second floor. The third floor featured a ballroom, two bedrooms, an enormous linen closet, and the servants' quarters. A section was reserved for the sewing room, and people came a few times a year to make the family wardrobes. There were seven servants, including a gardener and handyman. On the southeast corner of the house were two octagonal rooms—the sunroom on the first floor and the other on the second floor, off the master bedroom.

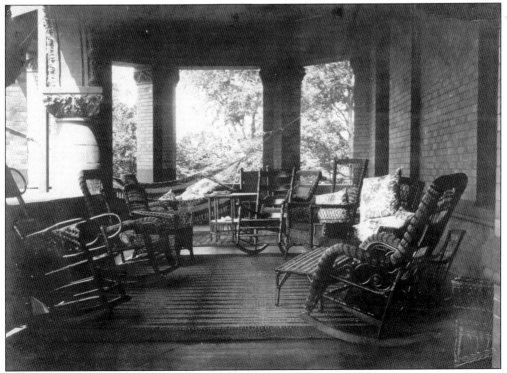

This photograph shows the side porch of the Lawrence mansion.

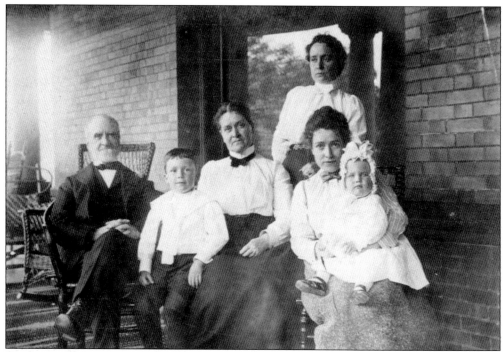

Harriet Collister Lawrence is seen here with her father, children, and grandchildren. Cora Brown is standing with Ida May James and her children sitting on the mansion porch.

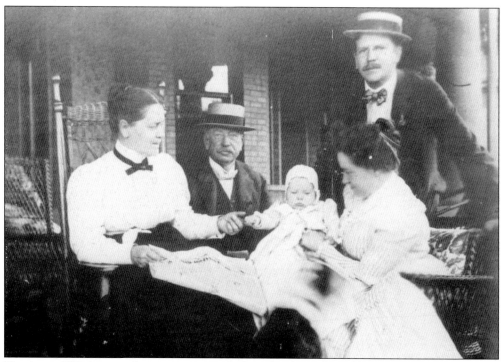

Harriet and Washington Lawrence pose with their daughter Ida and her husband, Walter James, and their baby Laura.

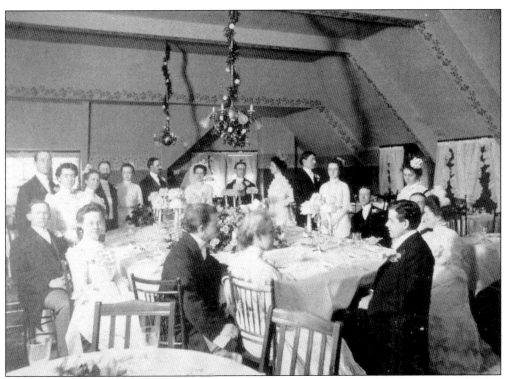

Washington and Harriet Lawrence's daughter Ella married William Mathews. This photograph is of their wedding reception.

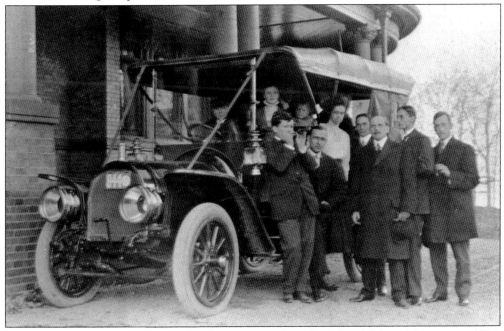

The Lawrence family gathers at the front portico for a Fourth of July celebration in 1900. Washington Lawrence is standing holding his hat. He is surrounded by his sons-in-law. His daughters and grandchildren are in the car with the chauffeur.

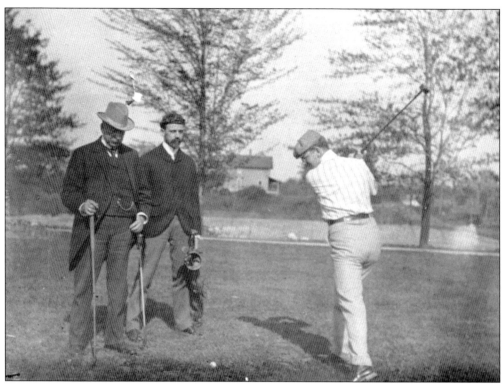

Washington Lawrence (left) is photographed here on the family golf course with his sons-in-law, Mathew (center) and James.

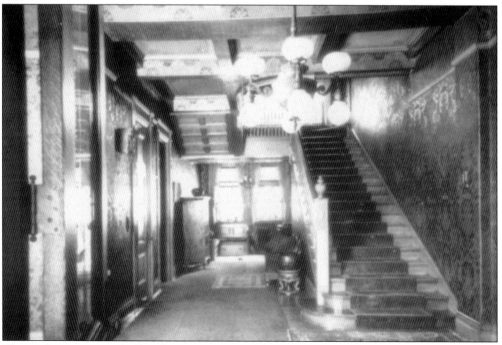

This is the main entry hall and main staircase of the Lawrence mansion.

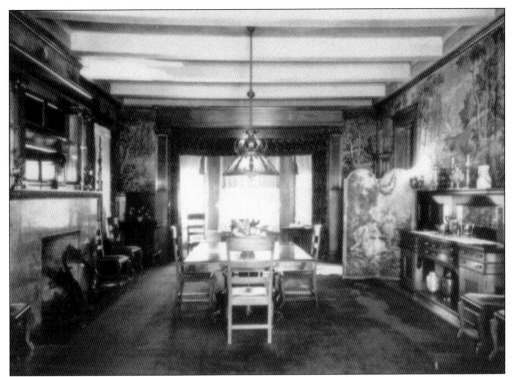

The Lawrence mansion's main dining room is pictured here.

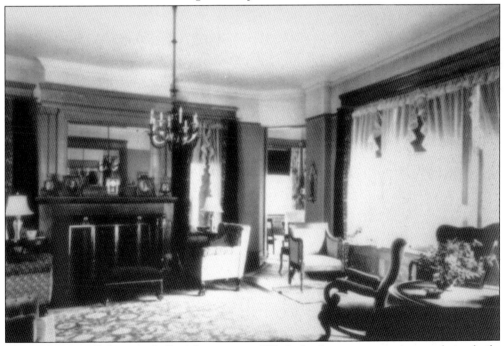

The parlor was off the main hall of the mansion. While the Lawrence mansion was being built, the family lived in a frame house on the property. This farmhouse was probably what was used as the clubhouse for the golf course when the main clubhouse was torn down.

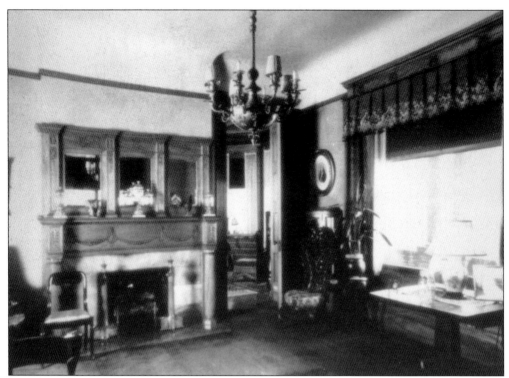

This was the Lawrence mansion's sitting room.

Washington Lawrence had a great love for horses. His daughter Irene Fuller tells the story of her father coming home one very dark night on horseback and crossing over the creek on the plank bridge. Road workers earlier in the day had removed the planks from this bridge leaving only the brace beams. His horse amazingly just slowed down and crossed the beam to take its master home.

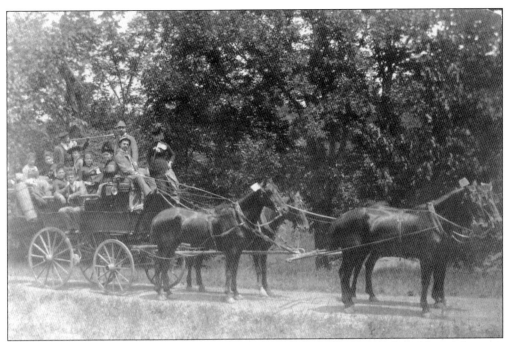

At this Lawrence family celebration, the horses are all decked out with flags. Notice the man with the horn standing in the wagon.

Here is one of the carriages touring the grounds of the Lawrence property. Notice the cottages in the mist.

Washington Lawrence, standing on the portico, bids farewell to his family.

On March 21, 1903, the colony reorganized as the Dover Bay Country Club. The clubhouse on the south side of Lake Road was built around this time with a changing of all the golf holes so they started and finished at the clubhouse.

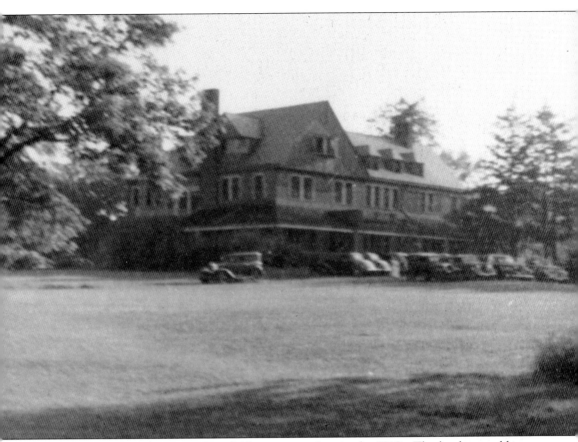

This photograph of the Dover Bay clubhouse was taken in the 1920s. The land was sold to a hospital in 1948.

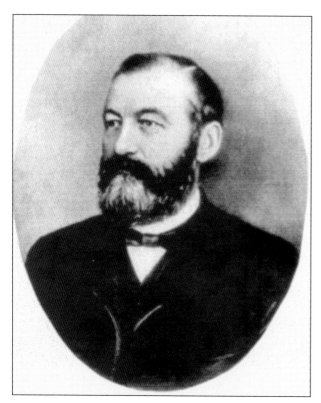

Prominent industrialist John Huntington (1832–1893) was a philanthropist and inventor. He was involved in the oil business, the sewer systems, quarrying, mining, the fire department, the Superior Viaduct, lake vessels, and construction of swing bridges on the Cuyahoga River. He served on Cleveland City Council for 13 years and also made an unsuccessful bid for mayor. So great were his inventions of refining oil that he united with others to form the Standard Oil Company. Huntington acquired a large fortune and never hoarded his wealth, instead giving liberally to charitable and benevolent organizations. One of John Huntington's biggest contributions was funding the establishment of the Cleveland Museum of Art. He is buried in Lake View Cemetery close to his friend Pres. James Garfield.

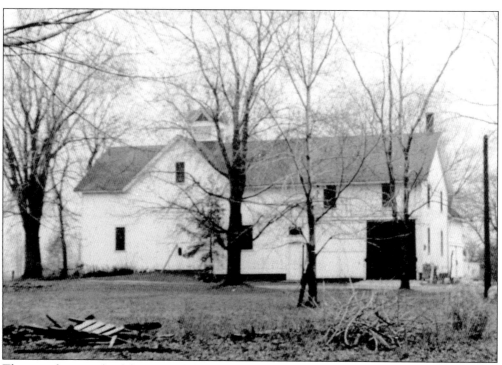

This is a photograph of the original Huntington barn, which burned down in the 1970s.

The Huntington estate provided housing for its workers. This house, which was located behind the caretaker's house, was torn down in the 1990s.

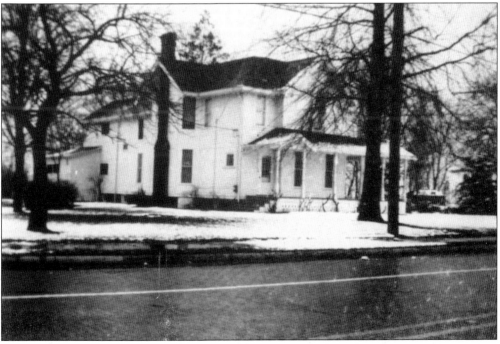

Several of the family's farmworkers lived in the house on the lake side of the Huntington estate. It was torn down when the Cleveland Metroparks enlarged the Huntington Beach public parking lot in the 1960s.

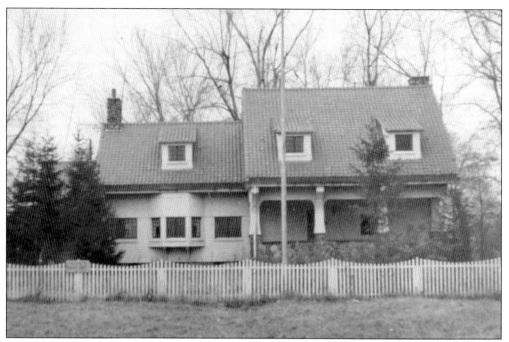

An original Huntington structure, the caretaker's house was built in the late 1800s across the street from the mansion and water tower. The Huntington caretaker house became the headquarters for Baycrafters, a nonprofit organization for the visual arts, in 1968.

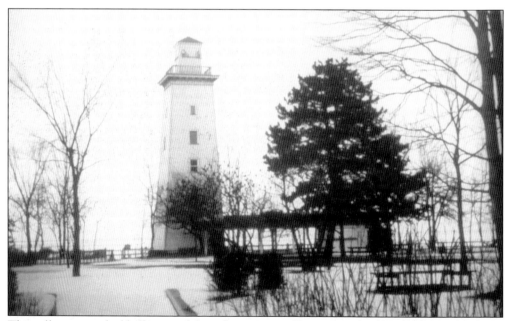

This tall tower on the bluff is one of the only remaining Huntington buildings. Although it looks like a lighthouse, it is actually a water tower, built between 1880 and 1890. It was used to store water to irrigate the orchards, vineyards, and gardens, which had unusual European botanical specimens. Some unusual trees still remain. The original stairway, water tub enclosure, and water pipes that connect the pump house to the tower are still inside the tower building.

Charles Rahl, pictured here, was the caretaker of the Huntington estate in 1925.

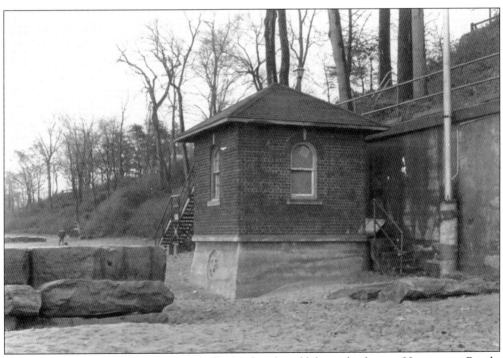

The pump house for the water tower is still a landmark and lifeguard refuge on Huntington Beach.

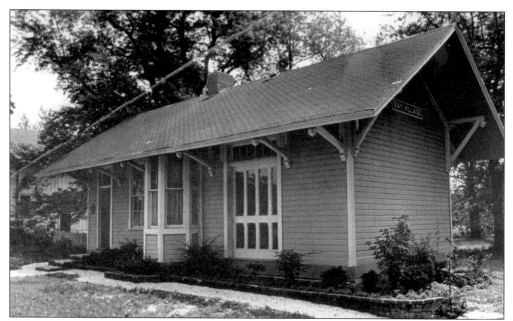

Huntington Reservation, located in the metroparks, has become a campus of cultural organizations open to all area residents. John Huntington would be proud of this entire complex. This Nickel Plate Railroad station moved from Dover Road to join the Baycrafters complex on the Huntington Reservation in the metroparks.

Sally Irwin Price manned Baycrafters for more then 40 years. She is seen here setting up a show, one of hundreds.

From left to right, Marsha Sweet, Sally Irwin Price, and Jill Funk pose in front of the Huntington barn doors to advertise an upcoming Baycrafters Gallery art show.

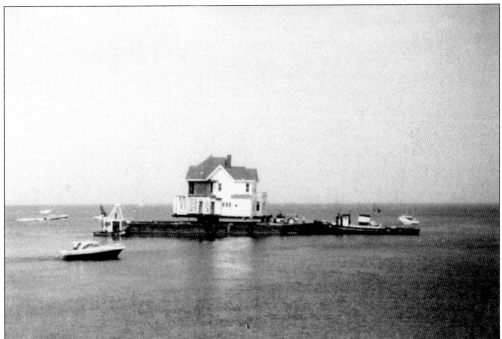

The Fuller house was floated down Lake Erie's Bay Village shore. It made a historical move, sailing into the Huntington Reservation. The company that moved the building won the worldwide house move award of 1984.

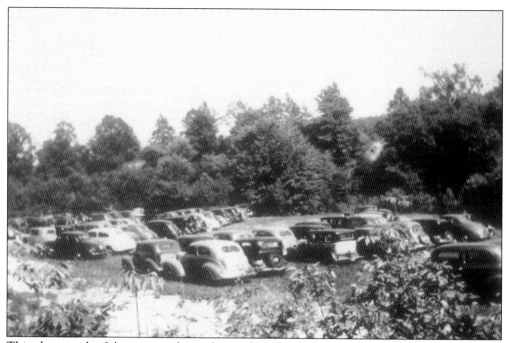

This photograph of the metropark meadow parking for the beach was taken in the 1930s.

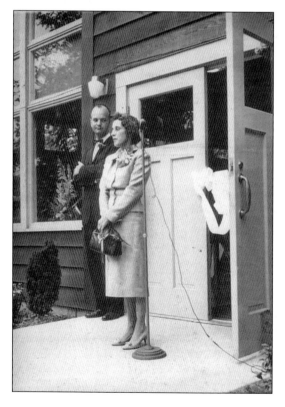

Alberta Fleming established the Lake Erie Nature and Science Center, a small museum with live animals and exhibits. It originated on the second floor of Rose Hill.

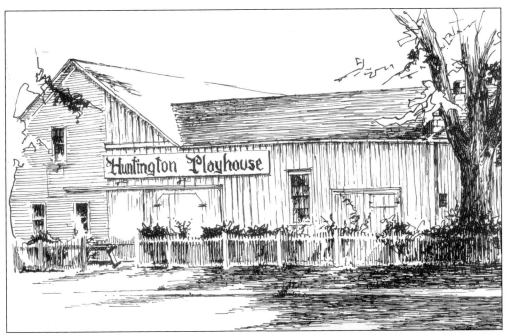

Holt Brown took over the Huntington barn and remodeled the building into a summer community theater, which burned down in 1970. The Huntington Playhouse was rebuilt and reopened in 1971. Three well-known cultural organizations are located within Huntington Reservation and are available for surrounding communities, an asset to the city of Bay Village. (Drawing by Jean Ruzsa.)

Marty Schickler (left) and Arthur Clark, along with Bud Binns (not pictured), took over the playhouse from Holt Brown.

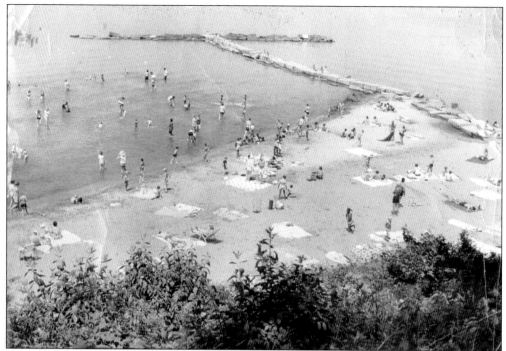

This photograph of people enjoying the beach was taken from the top of the cliff in Huntington Reservation.

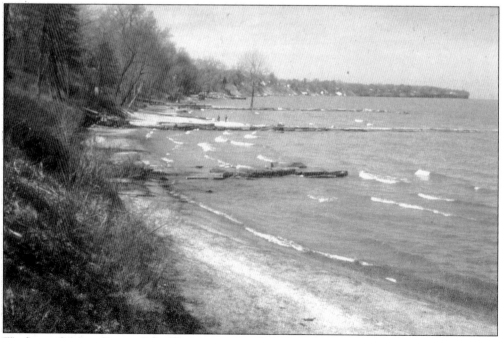

The beautiful shoreline and the Huntington Beach piers are captured in this photograph.

Four

CRIME AND PUNISHMENT

This illustration depicts the Fuller house, as it is known in the village. The Fuller house has quite a history. It was on this porch that Sam Sheppard was arrested for the murder of his wife. (Drawing by Marge Gulley.)

One afternoon in mid-August 1943, twin boys James and Charles Collins were hitchhiking for a ride back into Cleveland. They were caddies at the Westwood Country Club. A Lakewood boy picked them up on Clague Road, and they were found dead only hours later in a wooded area at the end of Sadler Road in Bay Village. Henry Hagert (left), 17 years old, was arrested and found guilty of the crime. He was the youngest man to be executed in the electric chair in Ohio. (Courtesy of the Cleveland Public Library.)

During Prohibition, liquor came across Lake Erie from Canada. Bay Village was one of many drop-off points. The boats would anchor out three-quarters of a mile off the shore, and young boys would swim out to take a bottle at a time. The boys had to be a certain weight and height, and they were paid 25¢ a swim. This is a story related by Mary Moffit about her brother-in-law, who was one of those boys. Moffit is now in her 90s. (Courtesy of the Cleveland Public Library.)

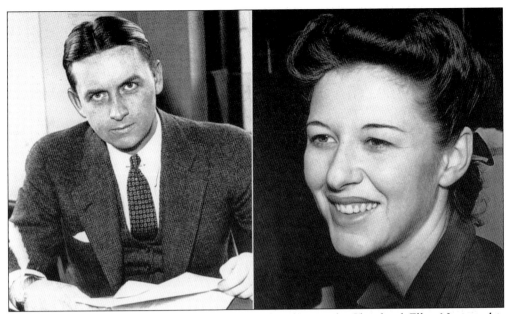

In 1936, Mayor Harold Hitz Burton hired a new safety director for Cleveland. Elliot Ness was his name. He had just cleaned up Chicago and captured Al Capone. Cleveland was in a bad way, and Elliot (seen above) was one of the youngest men employed in city government at 33 years old. He lived in Bay Village with his first wife, Edna Ness. She was not enthusiastic about Elliot taking the job in Cleveland but felt it was her duty to be with him. Because Elliot was married to his job, the marriage did not last and Edna eventually moved back to Chicago. (Courtesy of the Cleveland Public Library.)

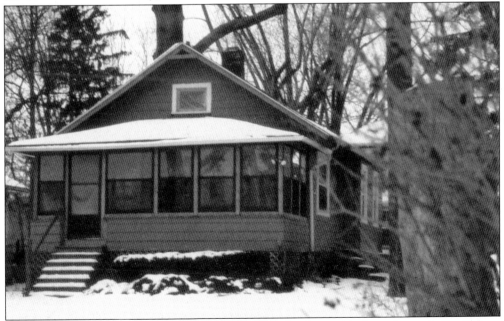

Elliot and Edna Ness lived in this cottage on Lake Erie behind one of the larger homes in Bay Village. When the couple separated, he moved out of this cottage. Bay Village was dotted with cottages. It was a summer retreat from the city, and the Lake Shore Electric was very good transportation.

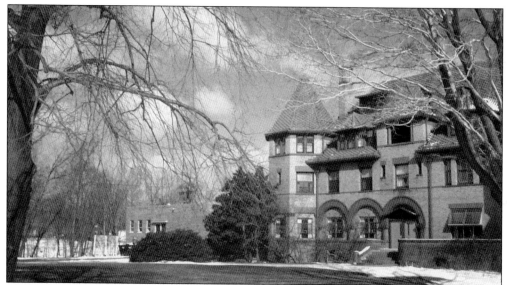

Sam Sheppard worked in this hospital, located in the old Lawrence mansion. In October 1948, the Cleveland Osteopathic Association purchased the old Lawrence mansion to accommodate its growing hospital. It moved from Cleveland, where it was operating a 50-bed hospital, to an 85-bed hospital with modern facilities. In 1952, it added a $385,000 west wing, which can be seen to the left of the picture. By this time, the whole Sheppard family was on staff, with Richard Sheppard Sr. being chief of staff. A portion of the new west wing opened on November 15, 1953. (Courtesy of the Cleveland Public Library.)

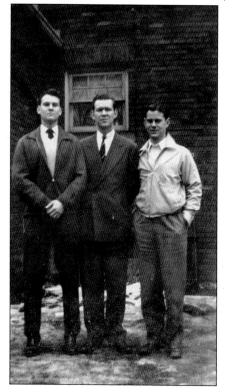

The Sheppard boys were known as the "Sheps" and did their undergraduate college work at Hanover College in Indiana. Then they went to California to get their medical degrees at the osteopathic medical school in Santa Barbara. The boys were a competitive group. Richard Jr., the oldest, is standing in the middle with Steven on the right and Sam, the youngest, on the left. Notice Sam is on his tiptoes. (Courtesy of the Cleveland State Library.)

Steven (left), Richard Jr. (center), and Sam Sheppard pose with friends. (Courtesy of the Cleveland State Library.)

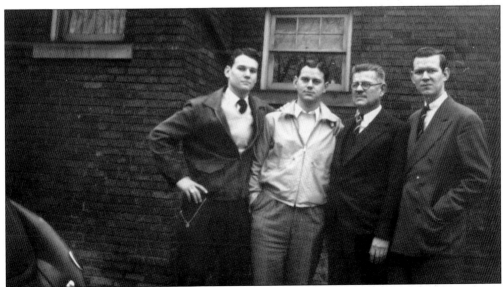

From left to right, Sam, Steven, Richard Sr., and Richard Jr. are all seen here at various stages of their medical careers. A family dedicated to medicine, the Sheppards served Bay Village and the surrounding communities for more then 30 years. (Courtesy of the Cleveland State Library.)

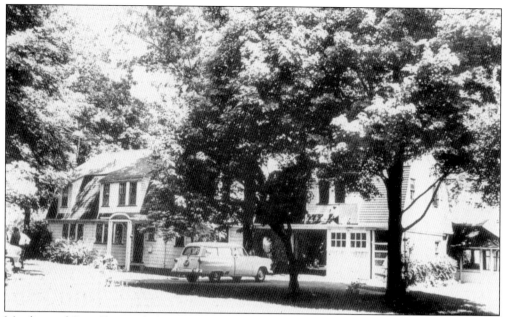

Marilyn and Sam Sheppard's home was about four miles down the road from the hospital. They lived in this house for about four years; it was a Dutch Colonial overlooking Lake Erie. The Sheppards enjoyed the lake, waterskiing, swimming, and boating. The house was once a summer home and had been converted to a year-round home. Over the garage was an apartment that was at times rented to teachers through the years. (Courtesy of the Cleveland Public Library.)

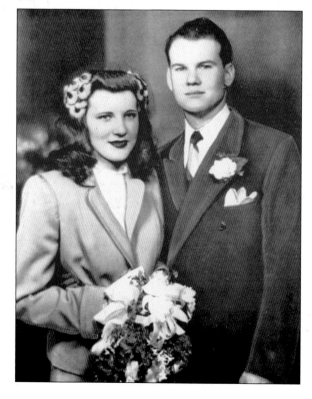

Marilyn and Sam Sheppard were married in the late 1940s. They moved to Bay Village in the early 1950s. Their wedding picture sat on the mantel in their living room at Lake Road, Bay Village. (Courtesy of the Cleveland Public Library.)

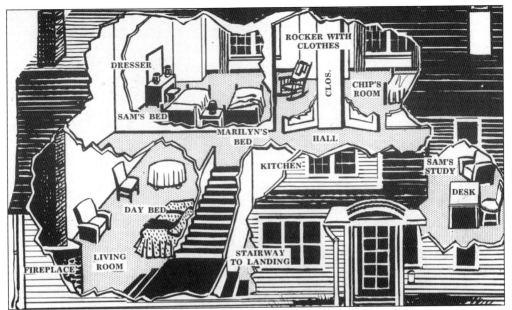

On July 4, 1954, there was a murder in Bay Village that was to become one of the most sensational cases of its time: the Sheppard murder. Everywhere one went, in the United States and even Europe, Bay Village was known. This is a drawing of the interior of the Sheppard house.

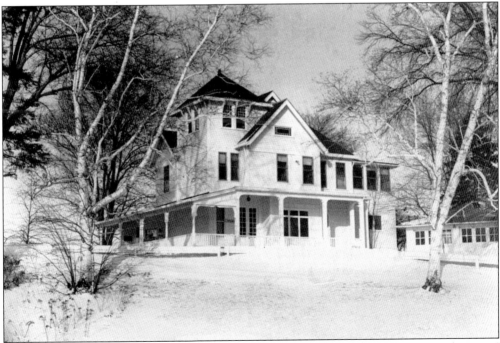

The Fuller house, as it is called in the village, was part of the Lawrence mansion compound called Dover-Bay. On June 30, 1954, the Sheppard boys moved their mother and father into this house on the hospital property. According to the timeline of Rich Sheppard's testimony at trial on July 10, 1954, Sam was arrested from the porch of his parents' home.

This photograph depicts Sam Sheppard showing the prosecutor where he said he was left unconscious in the Supreme Court case of *Sheppard v. Maxwell*. Sheppard remained in prison for 10 years while the case was ongoing. During this time, the case was appealed and resulted in the Supreme Court of the United States' landmark decision to strengthen the rights of defendants. Its decision established an individual's right to receive a fair trial protected from the influence of prejudicial news accounts. Sheppard was finally released, and the killer was never found. (Courtesy of the Cleveland Public Library.)

Harvey Yoder was Bay Village's first full-time marshal. He rode a motorcycle, and when he graduated to a Ford sedan, he was hit and killed on the railroad tracks while testing the car on July 14, 1925.

Five

A WAY OF LIFE

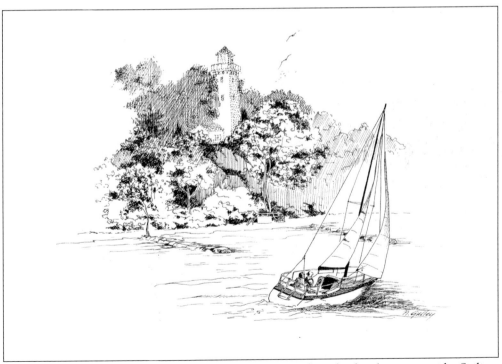

Wonderful sunsets, beaches, cliffs, waterfalls, streams, and creeks dot the countryside. Sailing, motorboating, swimming, and water sports of all kinds are popular activities in Lake Erie, the backyard of Bay Village. (Drawing by Marge Gulley.)

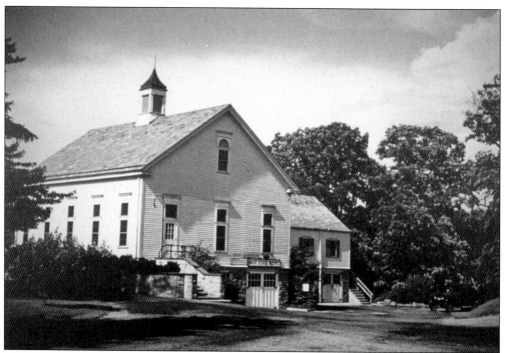

The fire department was housed in the bottom of the community house, or the original Cahoon barn. Before that, there was only a volunteer fire department.

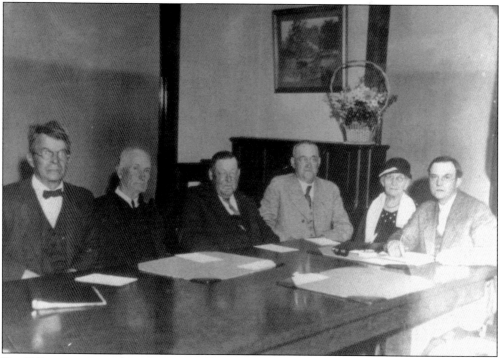

Bay Village city councilmen Burrett Sadler, Calvin Osborn, Henry Koch, Frank Meilander, and Eunice Osborn pose for this photograph.

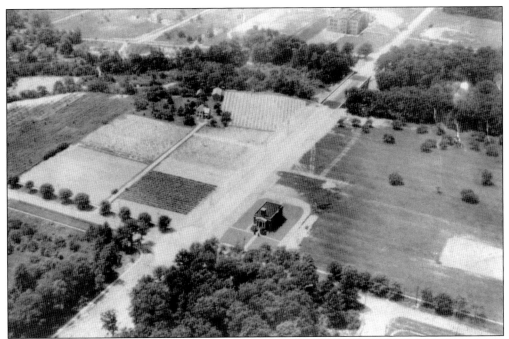

This view of Bay Village City Hall was taken in the 1930s. The land for the town hall was given to the village by Ida Cahoon in 1914. It remains the seat of Bay Village government to this day. Over the front door of city hall, it reads, "The Village of Bay."

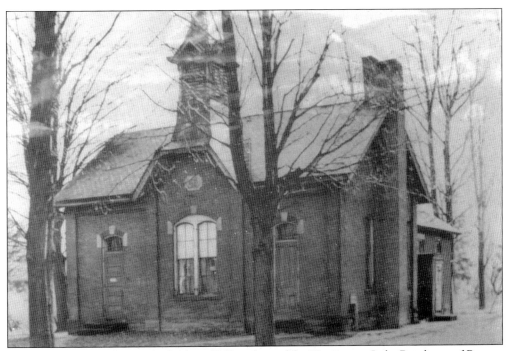

The redbrick schoolhouse was built in 1869 and stood for 72 years on Lake Road east of Bassett Road. After new schools were built, this building functioned for community events, as a meeting hall, and even as a community theater.

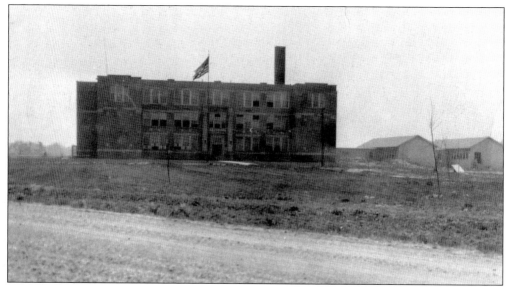

Parkview High School was the next school to be built, and it was ready for occupancy in 1922. It originally was two stories, and the third floor was added in 1925. The two white buildings at the back were moved across the Wolf Road bridge and are now Bay Way Cabin, a youth center.

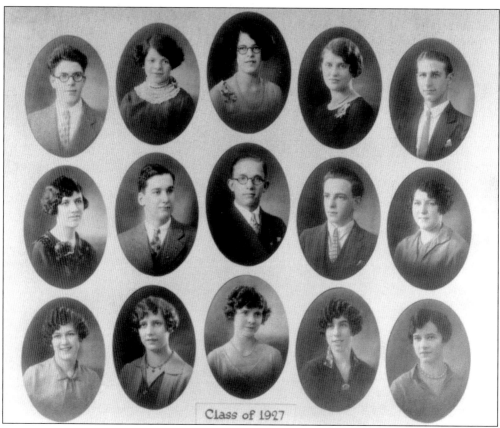

Class of 1927

Bay Village's first graduating class from Parkview School, in 1927, is pictured here.

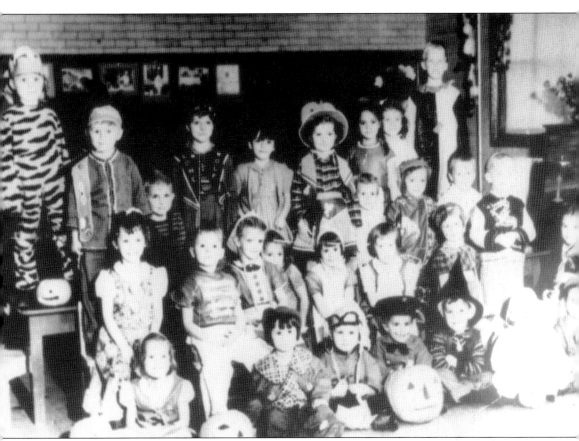

Here is the school's first kindergarten class, under Marie Ranney's tutorage, in 1941.

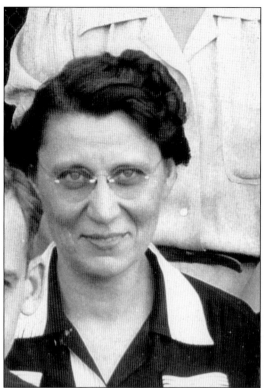

Marvel Siebert spent a long career in the Bay Village school system. She had a great influence in setting the high standards that are still in existence today in Bay Village schools. Siebert taught English, was the basketball coach, and was a hero to many of her former students.

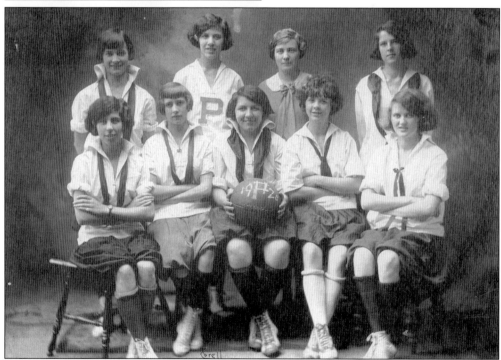

The champion girls' basketball team had this photograph taken in 1926. It is believed that if the whole team had not come down with the flu, it would have won the state championship.

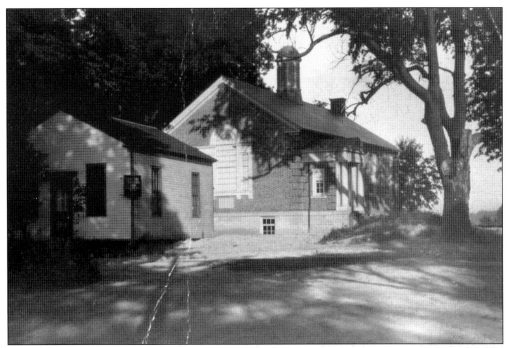

The Sadlers donated the land for Bay Methodist Church, and the small frame church was built in 1840. The brick building was constructed in 1909. It is still standing.

At the corner of Lake and Hall Roads (now Route 252/Columbia Road) stood an early schoolhouse. In 1924, the Presbyterian Church bought the property for $2,025 and remodeled the building into a church.

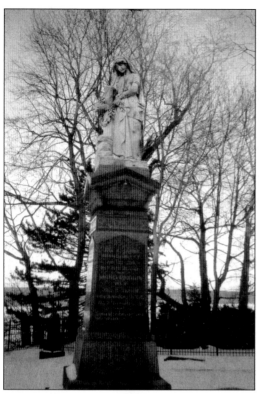

Lakeside Cemetery is a small piece of land situated on the north side of Lake Road overlooking Lake Erie. Pictured here is the tallest monument in the cemetery. The Bay Village Historical Society has published a book about the families buried here. This property was given by the Reuben Osborn family.

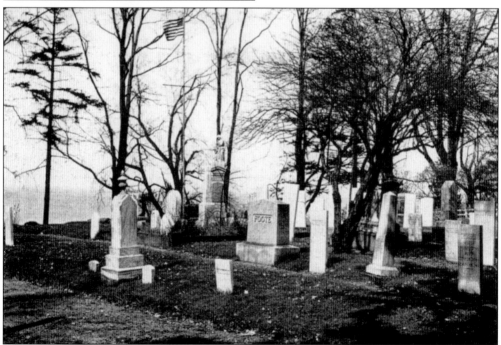

All the early notable families of the village are buried in Lakeside Cemetery. It spans five wars: the Revolutionary War, the War of 1812, the Civil War, the Spanish-American War, and World War I.

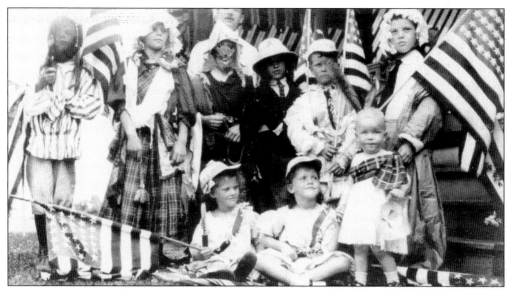

A Fourth of July gathering for a parade at the Dover Bay Colony dance pavilion is pictured here.

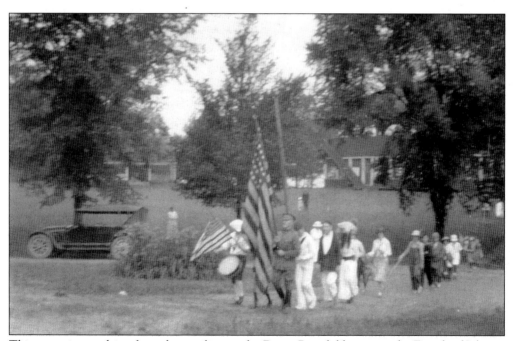

This group is marching from the pavilion to the Dover Bay clubhouse on the Fourth of July.

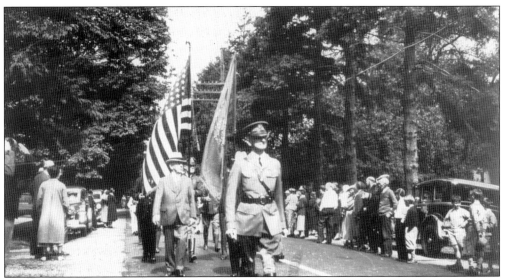

A Memorial Day parade marches from Lakeside Cemetery to Cahoon Memorial Park in the late 1930s.

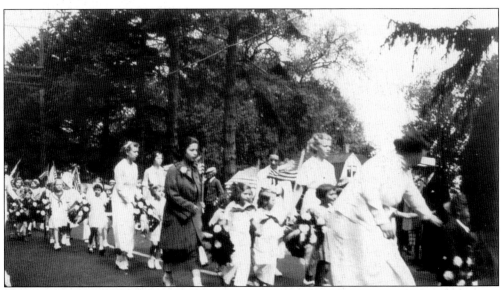

These children walk with their mothers, carrying wreaths and flags for the graves at Lakeside Cemetery on Lake Road during the Memorial Day parade.

This picture shows the Wischmeyers on the Fourth of July. The American flag was always flown at the Cahoon family reunions held on the Fourth of July. This is a practice that is still Bay Village tradition. In Cahoon Memorial Park, there are fireworks on every Fourth of July, and if the Fourth falls on Sunday, the fireworks are always rescheduled for another day due to the Cahoon will.

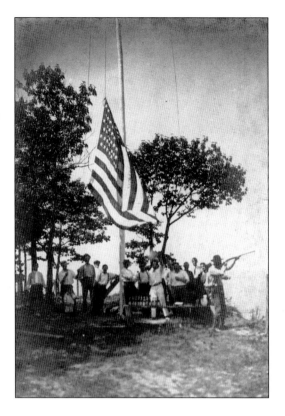

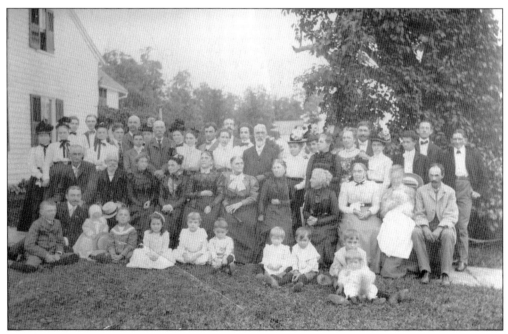

Family and friends join together at this Cahoon family reunion.

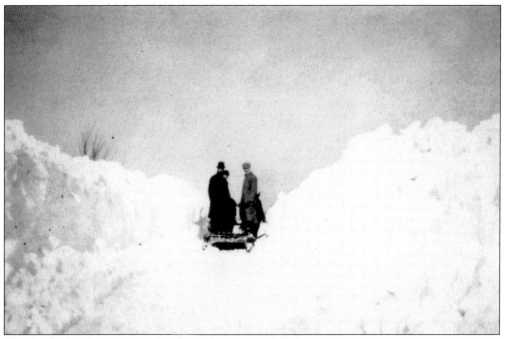

The Starke family is seen in the November storm of 1913.

The November storm of 1913 raged for three days and brought everything to a standstill. Three Bay Village families stand on top of a roof on the Starke family farm.

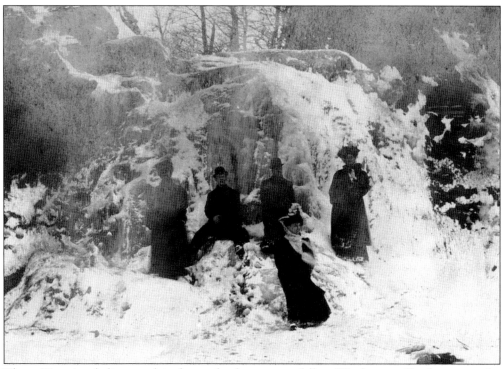

These Victorian ladies stand in front of a frozen waterfall at Wischmeyer Creek next to the Wischmeyer Hotel.

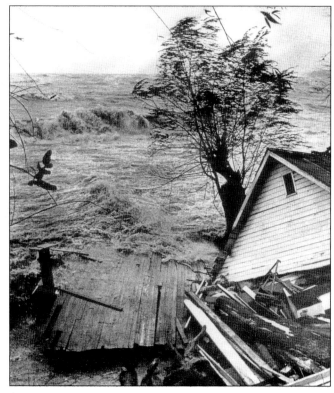

One of the Drake cottages is shown on the beach after a tornado off Lake Erie struck.

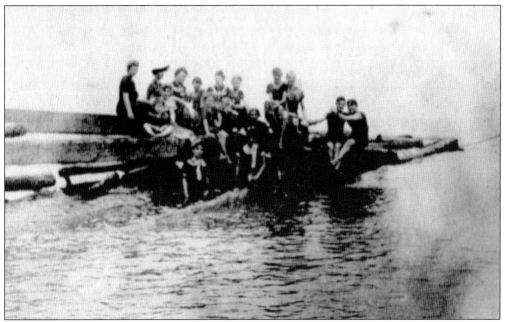

Members of the Wischmeyer family sit with friends on their pier on a warm summer day.

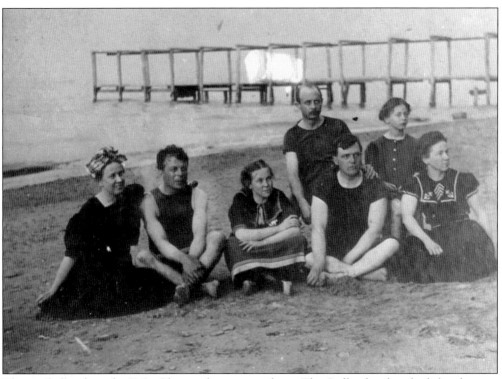

The sandy beach at the E. L. Gleason farm is seen here. The Sadler family, which lived across the street, took advantage of this sandy beach. Burrett, Daisy, and Jessie Sadler and friends are seen here on the beach at E. L. Gleason's motorboat pier at the end of Bassett and Lake Roads.

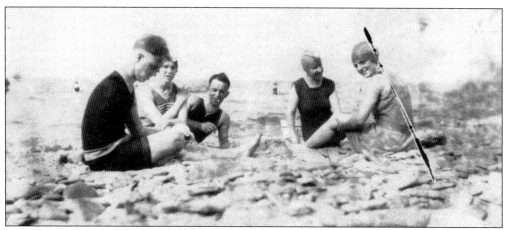

From left to right, Tom Irwin, Effie, Herb Werdel, Ruth Orr, and Emma Irwin are pictured here on the beach east of the Lawrence estate.

Friends and family on the Wischmeyer pier watch the glorious sunset and the lake. Sitting on the far right is Henry Wischmeyer.

The beach easement at stop No. 36 can be seen in this photograph of the Case family on the beach, with Eagle Cliff in the background.

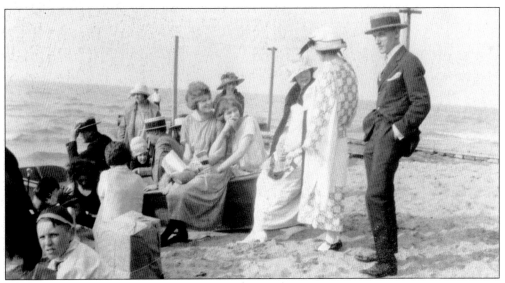

Participants in the Union Trust picnic enjoy the beach.

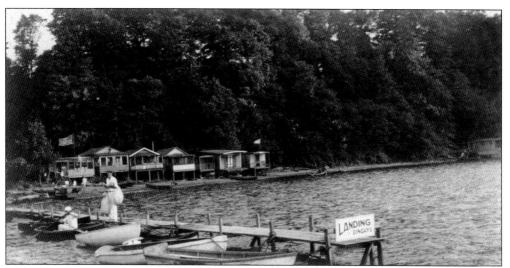

The Drake cottages' sandy beach and pier at the end of Bradley Road are seen here.

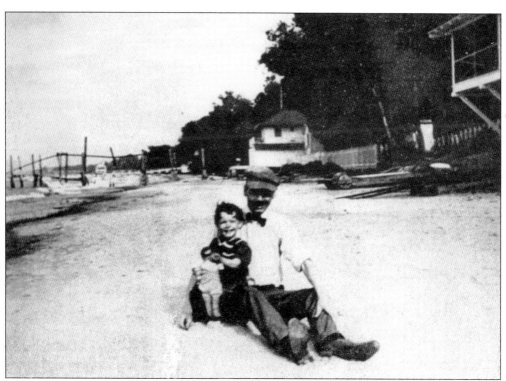

Here is another shot of the Drake Beach cottages and pier.

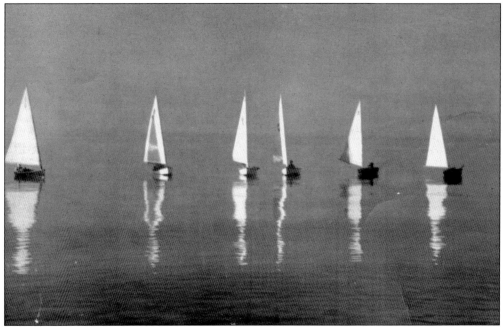

The *Hobo, Loafer, Tramp, Gypsy, Roamer,* and *Gale* were the names of some of the sailboats in the Bay Sailing Club. Each boat had a number: B-1 was the *Bum,* B-4 the *Wanderer,* B-6 the *Restless,* and B-8 the *Vagabond,* which were owned by H. Ruby, Miller, Asher, and the Smith boys. (Courtesy of Bob and Merle Asher.)

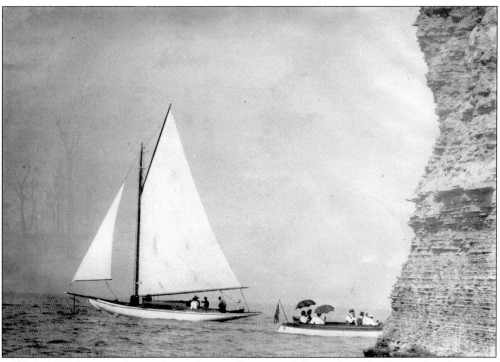

Guests were taken for a boat ride on the Wischmeyers' sailboat along the shore of Rocky River.

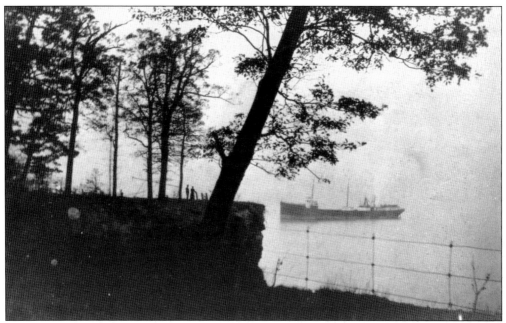

This ore boat is stuck in the mud off Eagle Cliff Point. This caused much curiosity, and many came to watch. Emma Darby and Charles Stone are seen here at the scene.

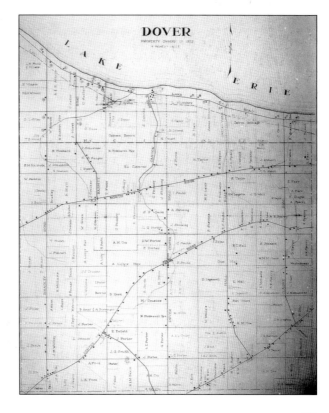

This map of Dover Township was created in 1852.

Across America, People are Discovering Something Wonderful. Their Heritage.

Arcadia Publishing is the leading local history publisher in the United States. With more than 3,000 titles in print and hundreds of new titles released every year, Arcadia has extensive specialized experience chronicling the history of communities and celebrating America's hidden stories, bringing to life the people, places, and events from the past. To discover the history of other communities across the nation, please visit:

www.arcadiapublishing.com

Customized search tools allow you to find regional history books about the town where you grew up, the cities where your friends and family live, the town where your parents met, or even that retirement spot you've been dreaming about.